Stephen Gan and Tobias Schweitzer

where
will we meet next?

Edition 7L

where

will we meet next?

for mom

foreword

The French writer François Mauriac once said that "one could only love land-scapes that have been seen by beloved eyes."

Seeing the world together makes every sight more memorable. Seen with eyes in love, even the most banal location can become an enchanting territory. Strangers cannot see these things the way that you see them. To you, everything can seem incandescently beautiful, as if seen through a wall of radiant crystal. One day or another, senseless circumstances may separate you, and even if nothing will have changed in essence, you will never look at the places you saw the way other people see them.

Today, thousands of miles and uncomfortable travel do not have to keep us apart. Anyone can stand side by side, looking at the world through the same eyes, from spotless places of untouched nature to the romantic (banality) of modern cities. Alone you may have a feeling of homelessness. Together you can make home wherever you are.

Every place visited can become a kind of heaven for the immigrants of two worlds, places where nature suddenly seems unconscious of its own beauty. The immortality in these moments is something you will always remember as the glory of youth.

Traveling is also about departure and loss. There is no anchor. You are free.

In this book, you allow strangers to share your happiness captured on paper. You might not need that as a proof and evidence of your love, yet you may need it in the future.

Happiness is a choice. Choose to be happy.

Karl Lagerfeld

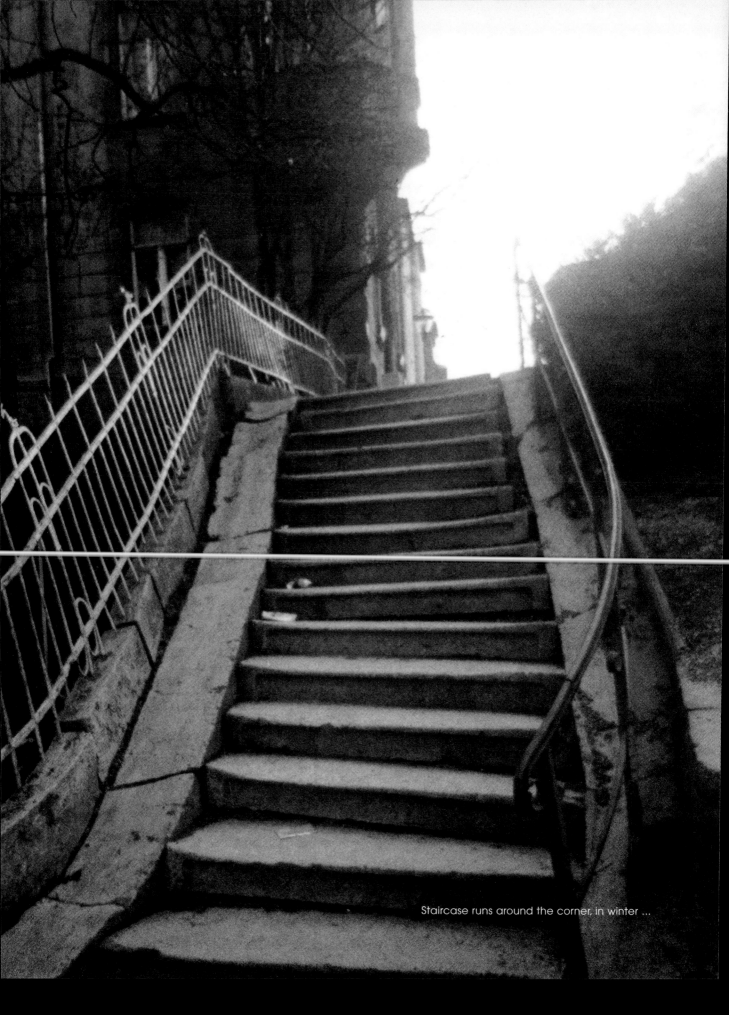

Staircase runs around the corner, in winter ...

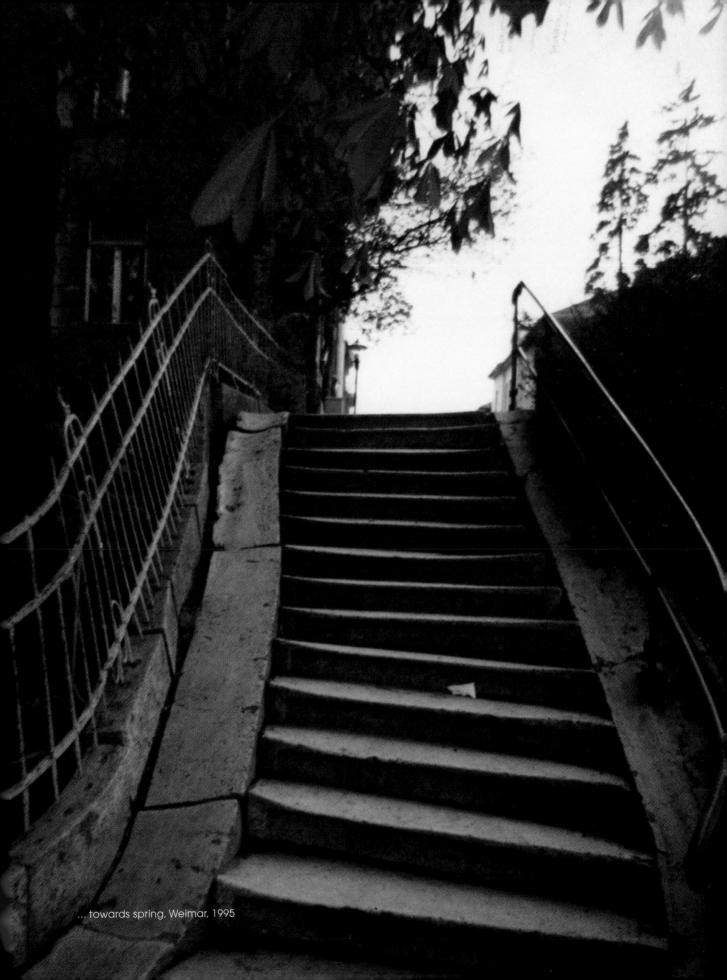

... towards spring, Weimar, 1995

background

Tobias Schweitzer London, early July 1999. I get off the plane, returning from Spain and I go straight to this small garden. I tuck my luggage behind a hedge and go into the small clinic's front desk to get the key for the shed.

Mowing the lawn, I begin to think about the reality of my situation. In London I had earned too little to survive. I knew already that this was my last day here. In the last week of July it would be time to go to Berlin to declare myself officially bankrupt. My landscape company in Germany had not been paid by two large contractors and I had taken the debt onto my shoulders. It had been my dream, my baby. In Germany, when you aren't able to pay back a debt, you become responsible for that debt for the next 30 years. I owe 420,000 DM, not including interest rates and lawyer costs. Everything seems impossible now, and my only option at the moment is to go to Switzerland where my mother has offered me a job. There I can, for now, earn enough to carry on.

In Berlin, my long-time friend Jan has moved into my flat. He has begun to refurbish everything. He is my most faithful friend, after having lived in Berlin for eight years. Now, he waits for me to return. He can't believe that I may not, and I'm trying to accept that I will live for a couple of years elsewhere. I feel sad, here in this garden I will be leaving very soon. I sit down on the dirty old stairs and drink my tea, and think. I believe in these dreams of mine... of landscapes, garden-spaces, homes, and for sure, strong friendships.

I think back to one year from now. I see Birgit and Wolf and the others sitting in our one room office that doubled as my bedroom. One of the workers, Christian, arrives with rolls, followed by Michaela and the other interns. I hear their fresh "Good morning Tobi," and then the sounds of coffee brewing in the kitchen. We have breakfast together, and discuss the work to be done in the day to come. Minutes later, we drive off into the Berlin morning to do our gardening... It was perfect. It was the company that I had striven for. Now it's gone. And I feel terrible, and lost...

Mowing the lawn, I have a strange feeling that something interesting will happen today... Just then, a man from a flat above calls out to me, "Are you a gardener?... A professional gardener?"

"Yes. I am."

"Could you look at my terrace?"

I go upstairs. I hear a few voices behind the door, and laughter. I can tell they are having fun. A man around forty opens the door. It seems he has just moved in. The place has an unlived in feel, everything is new... but in some way this flat reminds me of mine in Berlin, open and airy and uncluttered. We start to talk about possibilities of designs for his terrace. Suddenly he asks me, "You aren't from Britain?"

"No, I'm German. I've been living in England for the past few months."

"From which part of Germany?"

"I'm from Berlin."

"Oh, that's fabulous. I will be there at the end of July for one week."

In return I say that I will be there at the same time.

"Could you help me when my colleagues and I visit Berlin at the end of the month? We'll need a guide."

Soon after, I leave, with his address and phone number in my pocket. The next morning I take the plane to Zurich to start my new job.

Stephen Gan New York, early July 1999: Mario phones from Paris one day and we decide together that we should be doing more travel stories for the publication. Dual purpose: inspiration for new location ideas and to give us an excuse to visit places one or the other of us had always wanted to explore. His first choice destination is Berlin. We choose to go during the last few days of the month.

A few days later, Mario calls again, this time from London, to say what luck he'd had. He'd met his neighbor's gardener, who turned out to be from Berlin. This man would be in the city during our visit, and had agreed to show us around. Neither Mario nor I know anyone there, so it comes as a relief that Mario has been fortunate enough to land us a guide. Now, I'm excited to be going to Berlin.

T I suddenly remember the man I'd met who was taking a trip to Berlin. I had misplaced his name and number in my move from London so I decide to send him a postcard, (which he still keeps):

Dear Mr. ?

Sorry for writing you but I had lost your number. If you still think about going to Berlin, it would be nice if you could give me a call here in Switzerland.

Your Gardener

A couple of weeks later I receive a call from Paris:

"Mr. Schweitzer, could you tell me the best way to get around in Berlin?"

I tell the woman,"Yes, I think the subway and buses are quite good in Berlin."

"No, sorry, but this is impossible. Could you organize a kind of van for about nine people, please?"

I'm quite surprised when she says that. Nine people! I cannot imagine why a photographer would need nine people for a personal visit to a foreign city. I wonder then if he is traveling to Berlin for a conference or a special art exhibition, and I begin to be a bit nervous, wondering what he might be expecting of me. After all, I'm not a professional tour-guide.

"Yes, alright," I say. "Before we hang up could you tell me please the name of the person I'll be looking after?"

"Yes, it's Mario Testino."

"Okay, that's easy to remember. It sounds like an Italian opera singer."

A few days later I call a friend back in London. I tell him about my next visit to Berlin which will be the last one, for now. I tell him that I am glad to have the chance to say farewell to my friends there, and that I will also organize my things, consolidating them into as few possessions as possible, carrying with me only what I absolutely need in the time ahead. Who knows when I'll be able to return to Berlin to live. I mention in passing I'll be playing tour-guide throughout the week, for a man named Mario Testino.

"What, Mario Testino?" he says with surprise.

"Yes, do you know him?"

"Tobi, he is one of the most famous fashion photographers in the world."

"Oh. Well it's only a favor, and I have a million other things to do while I'm there. By the way, please say hello to London for me. It had begun to feel like a true home, and I'll miss it being there living."

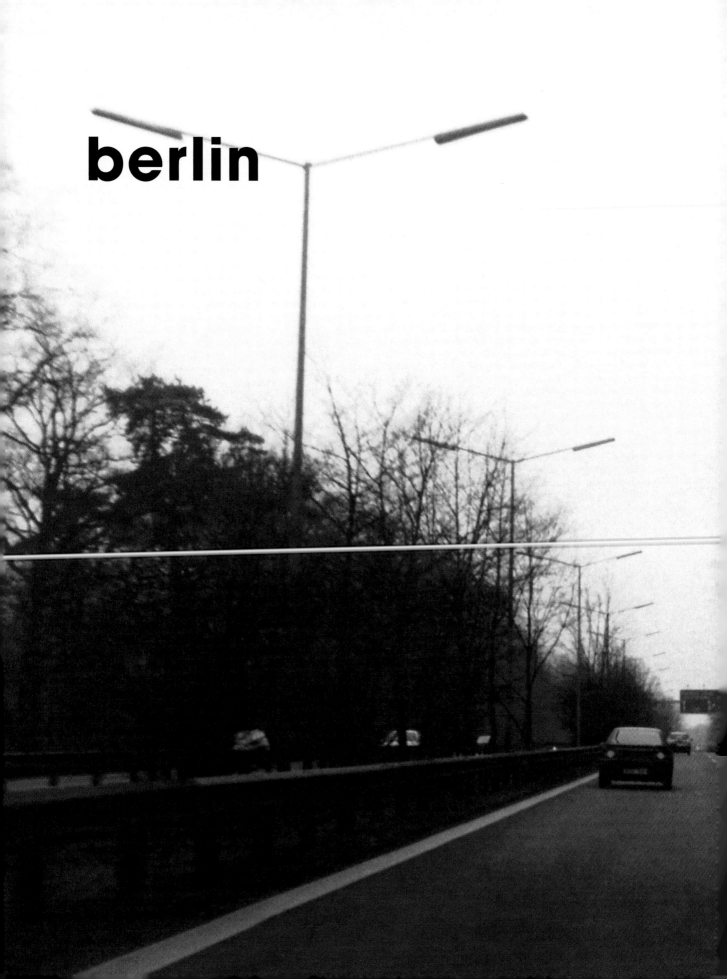

Autobahn, Berlin

T I arrive at the airport in Berlin in the early morning. I'm so happy to be here. The language is familiar and welcome. It's nice to be back home, even if only for a few days.

First thing, I need to pick up the van that my friend Wolf has already ordered. The woman with the rental company, who I've known for years, doesn't want to let me take the car because I don't have a credit card any longer. After long, heated telephone discussions between her and Wolf, she allows me to take the van.

Right after this I find myself in trouble again. I go shopping for new blades for my razor, which cost about five German marks. I try to pay with my sister's bank card that she has lent me, but when the cashier realizes that it isn't mine card, a huge affair develops over these five marks. At last, after lots of explaining and pleading, they let me leave.

Discouraged, I go to my flat. But Jan, my old roommate, had had the locks changed. Like a thief, I have to break into my own flat. Exhausted, I lay down on the bed and fall desperately to sleep.

So this is what it's like to be back here.

At noon the next day, Mr. Testino arrives and we go straight to the Hotel Adlon, which is the finest and most expensive in Berlin. Right away the program starts, and the group is moved through a finely-planned, fast-paced week of happenings. A woman from a German magazine has prepared everything. We go to all the most posh and trendy places, a side of Berlin I am certainly not used to. Galleries, restaurants and so on. This is not the Berlin I know and love. When we arrive at the first nightclub it is one of those with doormen, which I despise. The entire ambience seems to say, "We let you in if you are good-looking and appear to have money."

Quite late I arrive home and my old friend Jan is waiting for me. He's a little upset that I hadn't returned earlier in the evening after so many months of not seeing each other. I begin to feel like I'm taking care of everyone and nothing is going my way.

The next morning is a big morning for me. I leave the flat to go to court for a hearing concerning my bankruptcy. They've already checked my apartment weeks ago, for valuable things. There have been people calling me up to say, "If you don't pay back right now we will…" I began to worry that next would come men in black suits standing outside the door of my flat. I feel like a criminal, and I know that I'm not, but the pressure, the feeling of desperation inside is growing stronger.

Berlin Reichstag

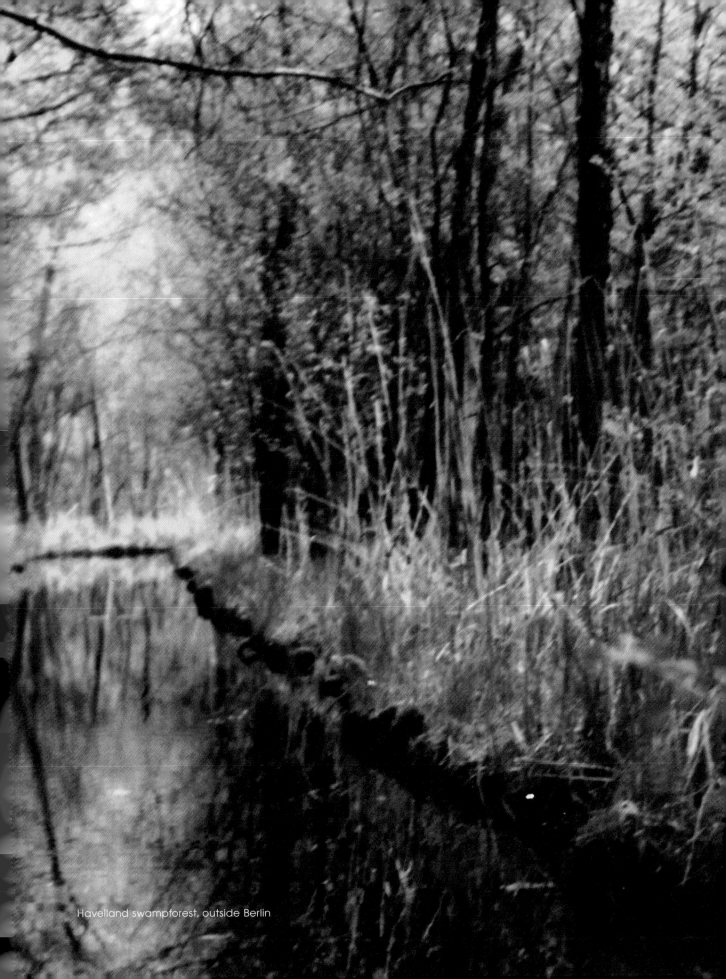
Havelland swampforest, outside Berlin

When I step outside I see the sunshine of this summer morning. The 27th day in July. Today I'm not in the mood to share it with the world. I wish instead I could hide myself behind a big wall, or crawl into a deep dark hole. Something, anything. But I can't, and later I have to carry on with these strange foreigners. Today I will meet someone who is arriving from New York. Another of Mario's team I have agreed to help care for.

S I arrive at the airport in Berlin, and learn that our "guide," this "Tobias," can't come to pick me up at the airport because he's got an appointment. That sort of thing never happens to Mario of course. He had arrived the night before and had already been taken around town. I get to the Hotel Adlon, shower, and go downstairs to the lobby. Mario is already waiting and with him is Tobias. I think he looks kind of fragile to be a gardener.

T When I look to the staircase a young man and a woman come closer to us. These are the Americans. The man, I think then, must be Mr. Gan, who was mentioned to me the day before. I had pictured him much older, but he's about my age. The crowd surrounding this Mr. Testino seems not to be as dry as I imagined, because I had thought at first it would be more like a stuffy business meeting.

S Within the first hour of walking around the city, Mario snaps pictures of me and Tobias. Separately. But standing near each other.

Tobias seems sweet. He buys me a yoghurt and a chocolate bar at our first stop after I mention in passing that I hadn't eaten anything since dinner on the plane the night before. He seems genuinely kind, but I wonder then if he has simply already been trained into being extra attentive like the rest of Mario's assistants. Regardless, he sure knew a lot about the city, and boy was he talkative.

T Driving around the city from one fancy place to the next, I'm still quite confused about my situation and about doing this "job." I'd agreed to show a man I'd met coincidently around Berlin for a couple of days, and now I'm feeling a little overwhelmed. There are all of these people, and the running around to and from locations that have little to do with the city that I know makes me question what I'm doing here. At the same time, I feel pretty pre-occupied with my own current problems, so much so that I'm having trouble enjoying myself...

Later on I start to talk with the American woman, Alix. Just to chat, she asks me about my profession and my reasons for being in Berlin. As if she has

View from Tobi's kitchen

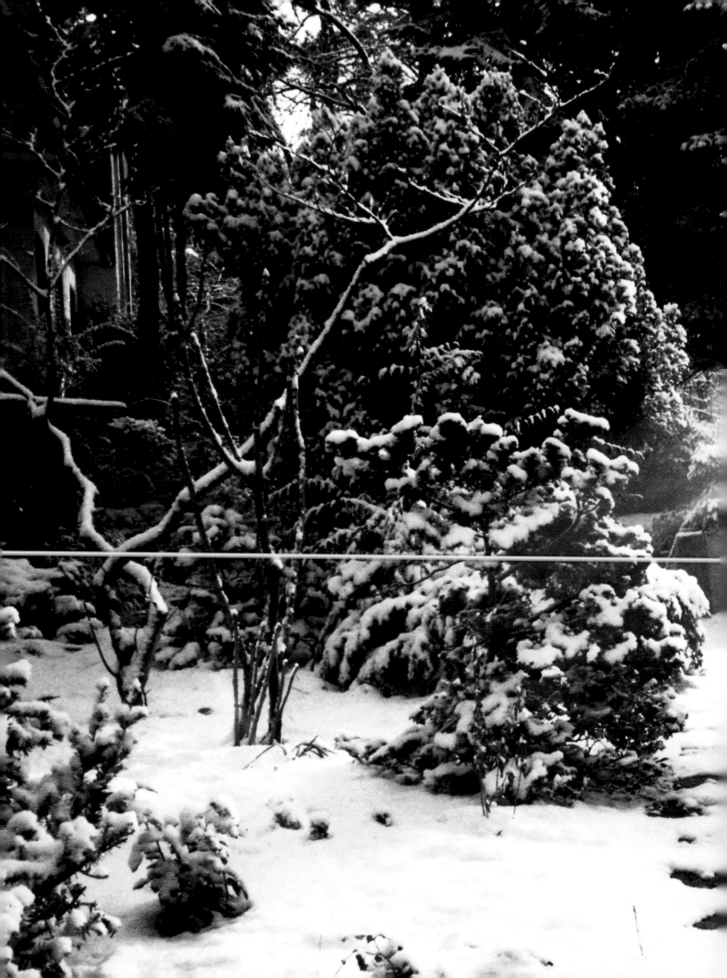

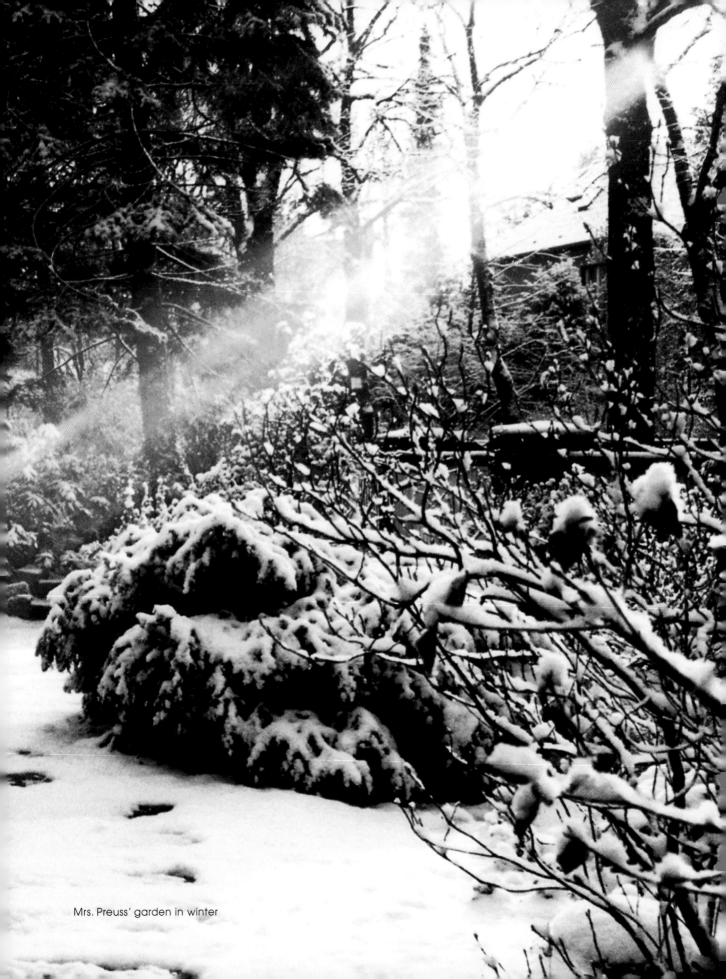

Mrs. Preuss' garden in winter

opened a reservoir, I start to talk about everything that has happened in my recent past. The more I tell her about my situation the more she becomes confused. I realize then that I'm laying a lot of fairly heavy stuff on pretty thick. Even so, as a response, she says that we could possibly work on something together in the future. With that kind gesture, I start to feel tears in my eyes.

S Sitting in a Berlin cafe, I discover that Tobias is actually in a bit of a delicate state... that he had just left London because something hadn't worked out, and had also just lost his company. Hmmm, kind of a bird with a broken wing...

 That night we were all taken to a club called Cookie's. Mario kept snapping pictures of Tobi and me as if he was trying to say something. I remember seeing a lot of flashbulbs, but they were all from Mario...

 We have a few drinks, and Tobi goes into some kind of Jägermeister marathon. I can't keep up. Before I know it, Tobi is doing a headstand in the middle of the dancefloor. Later on, I learn that, like a seal, he does that when he's happy or when he's relaxed. Or, I guess in this case, when he's drunk. We all have a great time, and dance into the early hours of morning.

 One thing I had noticed earlier during the day was that Tobi, aside from seeming a bit sad, was also unsatisfied with what we were seeing. What he kept referring to as a "posh" side of Berlin. So that night, instead of going back to the Adlon Hotel, I went with him to his apartment. It was an old building, the rooms had high ceilings and very simple furniture. Definitely not "posh". The yellow walls reminded me of an apartment I had lived in New York City. Lying in his bathtub, which was strangely placed in the corner of his living room next to the windows, he asks me, "What do you think of Berlin so far?"

 "From what I've seen, I love it."

 "...And what do you think of me?"

 Before I can think of what to say, he says, "Why do you like me?... We are from two totally different worlds..."

 I couldn't answer. All I thought to myself was, "What are you saying,... it's a relief to meet someone different..."

 The sky is just starting to turn a shade lighter over the old buildings. At that moment, Tobi makes a grand gesture. "Look out the window...," he says. "That's Berlin. The real Berlin."

Tobi and I do not leave each other's sides for the next four or five days. I wonder if he really enjoys being with me as much as it seems or if he just

Mrs. Preuss' garden in autumn

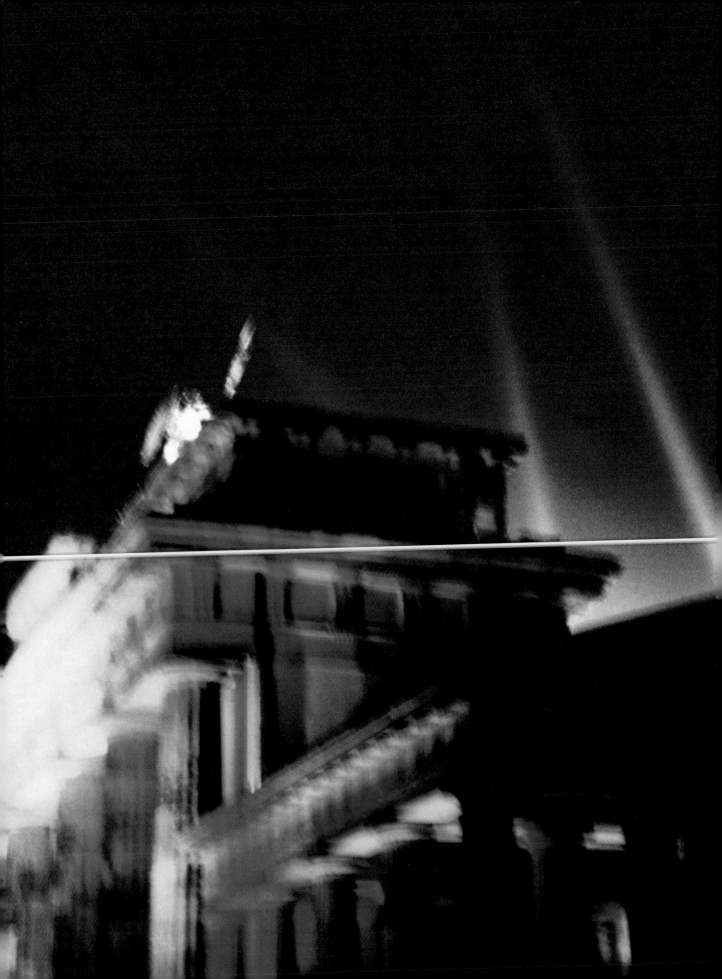

feels like he's got to be a good host. I decide just to relax and immerse myself in these experiences in this new city, and stop asking myself so many questions.

One day we all go to have a sort of "fashion lunch" with someone. I glance over at Tobi and although he's trying to hide it by making gracious conversation, I know he's terribly bored. As soon as we leave the restaurant he says, "Enough of this, come with me."

We drive through the city and stop finally somewhere near a park. Then he says, "Take your clothes off, we're jumping in the lake."

Lakes in the middle of Berlin? I hadn't imagined that. But I do as I'm told, even though I've never jumped into a lake before.

When I finally climb out to sit on the bank for breath, I think to myself, "swimming in this lake in Berlin is thrilling. I love it." But for a moment then I sense that Tobi is sad and feels alone. I figure he's been through a lot lately and I try to allow him a moment of peace to himself, and just enjoy the wonder of being in a lake for the first time in my life.

The next day is my last in Berlin. No more planned tours. Tobi is glad to have the opportunity to show me a little more of "his" Berlin.

We go to Berlin's Central park, the Tiergarten. Walking through with Tobi is like walking with Encyclopedia Botanica... "Now that's 'Rubus fruticosus'... ." That name I remember because it sounds especially funny to me. Next, we have breakfast in practically the center of this beautiful forested park, at the Cafe am See. I understand more about why Tobi loves these sorts of spaces.

Then he brings me to the Bauhaus museum and surprises me with how much he knows about every piece in it. I think to myself, "Wow, these Europeans, always trying to impress Americans with how informed of their culture they are, and how much they love it." He talks about light, and composition and minimalism and graphic qualities, "points and lines", and how he's used these principles in his landscape work. I keep thinking of how similar our work is, when it's boiled down to just philosophies, and I wonder how he would apply all he knows to doing something like a book one day. Would he approach it the way I would approach designing a garden?

Later that day he drops me off at the hotel and I meet up with Alix to go to the airport to catch our flight back to New York. He tells me as we part that he'll be flying that afternoon also, to his mom's in Zurich, and that we'll see each other at the airport.

But standing at the airport waiting to leave for New York, I realize that the next flight for Zurich is not for another hour and a half. So I say, that's it, great, we'll probably never see each other again.

Brandenburg Gate, New Year's Eve 2000

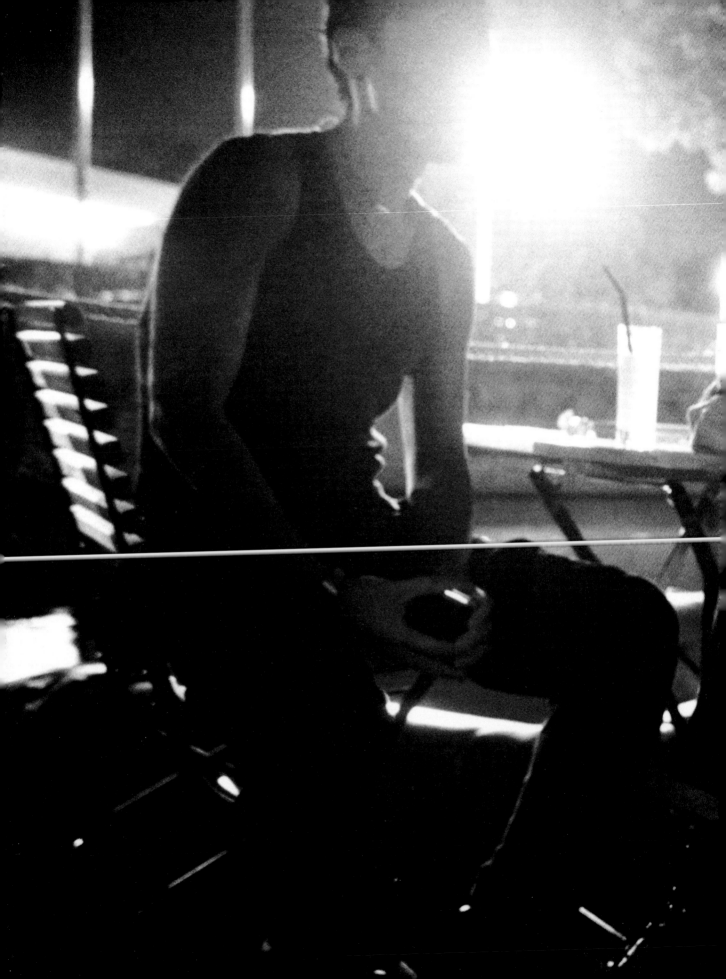

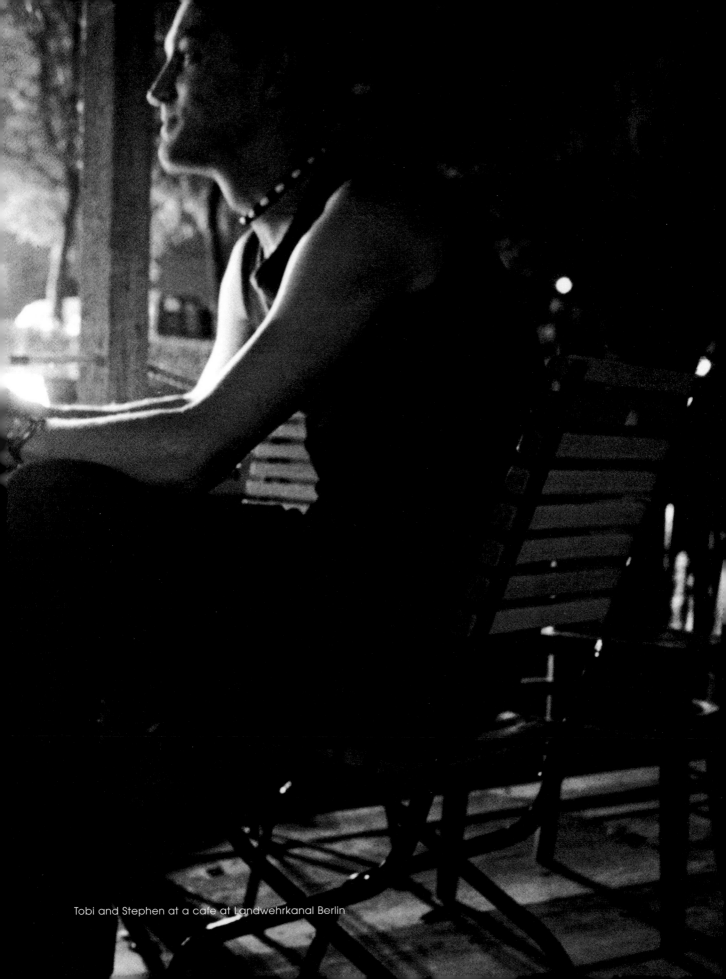

Tobi and Stephen at a cafe at Landwehrkanal Berlin

I figure that there's only one possibility. Now it's a Friday, about 4:30 in the afternoon, and my plane's leaving for New York in a few minutes. Meanwhile, Mario's office is closing down for the month of August. I phone his assistant and ask her if she has a number for Tobias, our Berlin guide, and she says she has one number but it looks like it's his mother's in Zurich. I say, "I'll take it."

So I return to New York with a bundle full of memories and a Swiss telephone number...

T After I return the van I have to pack together the things in my flat. It's my last chance to take from here things essential in my near future. I'm hurrying, but I don't want to leave. When I see all my memories as pictures, books, and little things it feels as if I am crossing the path of my whole life in just a few minutes to say goodbye. A lot of them I have to trash, because I don't know how long this flat will be mine. I keep getting stuck; should I keep this? I guess I need to let it go... On the other hand, it's important for me today to let go a little bit, realize that what's past is past. Now, something of my past will follow me as I leave Berlin, but that does not include so many things I can hold in my hands. I know that for a while, I will remember certain possessions of mine.

Finally, there are a couple of minutes left to say goodbye to my Berlin friends who I won't be seeing again for... who knows how long? I try to make as many phonecalls as possible, but time is too short and I am unable to reach them all. Most of them are quite disappointed that I hadn't shown up during the last week. Acting the tourguide every day all week and meeting Stephen hadn't left me much time for them. I feel bad for that. Checking my ticket I realize that I will also miss Stephen, because he will have already left. It was ridiculous of me to think that I would make it to the airport in time to say goodbye.

Now, I walk out the door with just two bags. I look back into the room one last time, turn, and close the door behind me.

Sleeping can behind a wooden hill, Weimar 1995

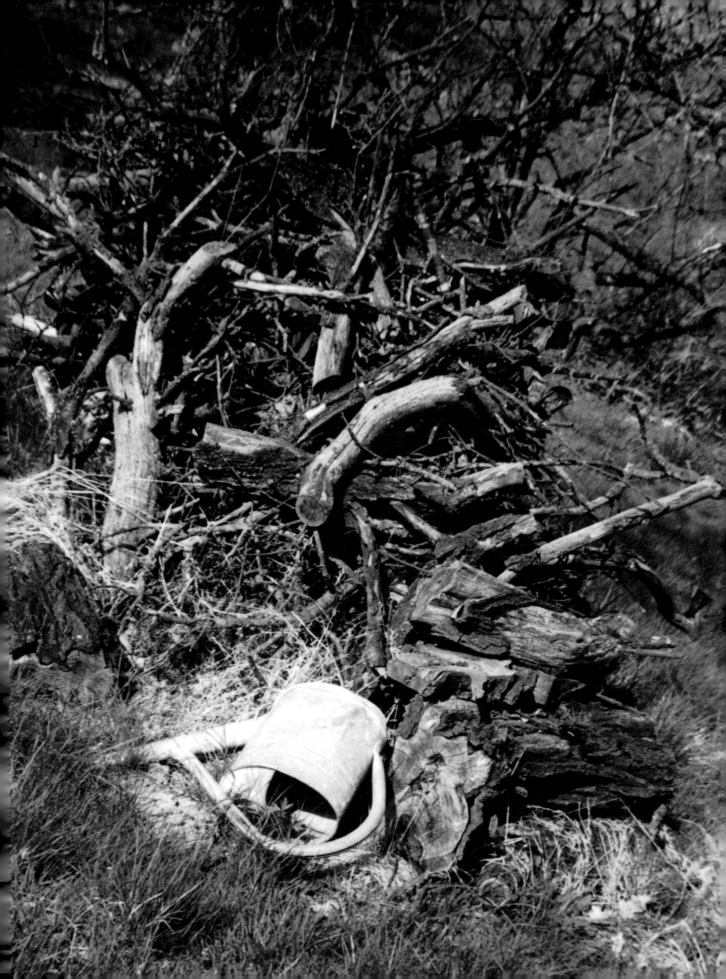

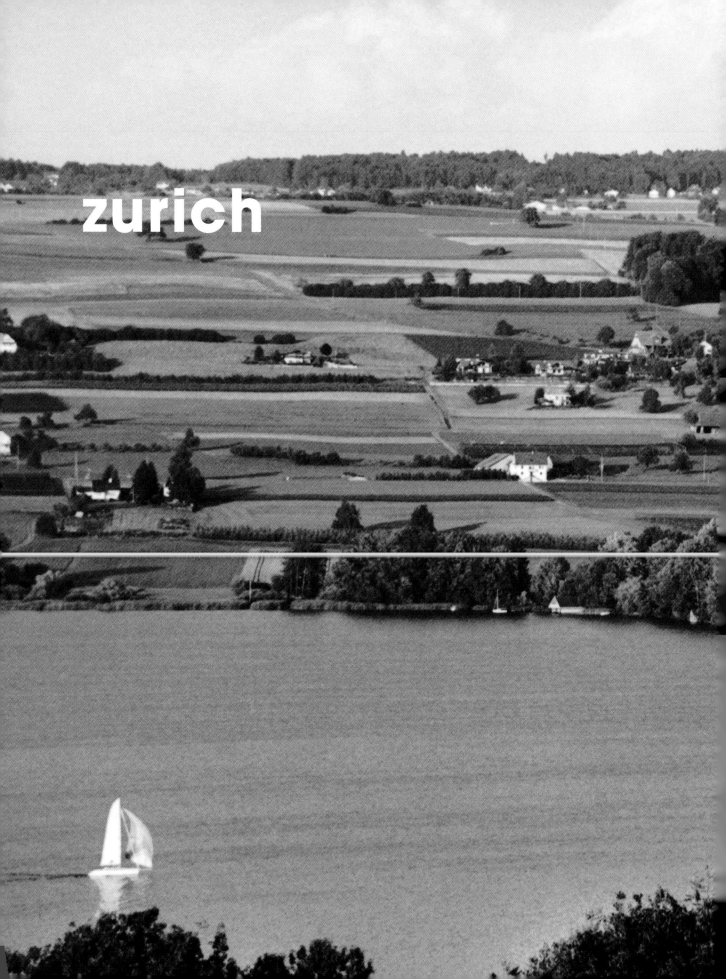

zurich

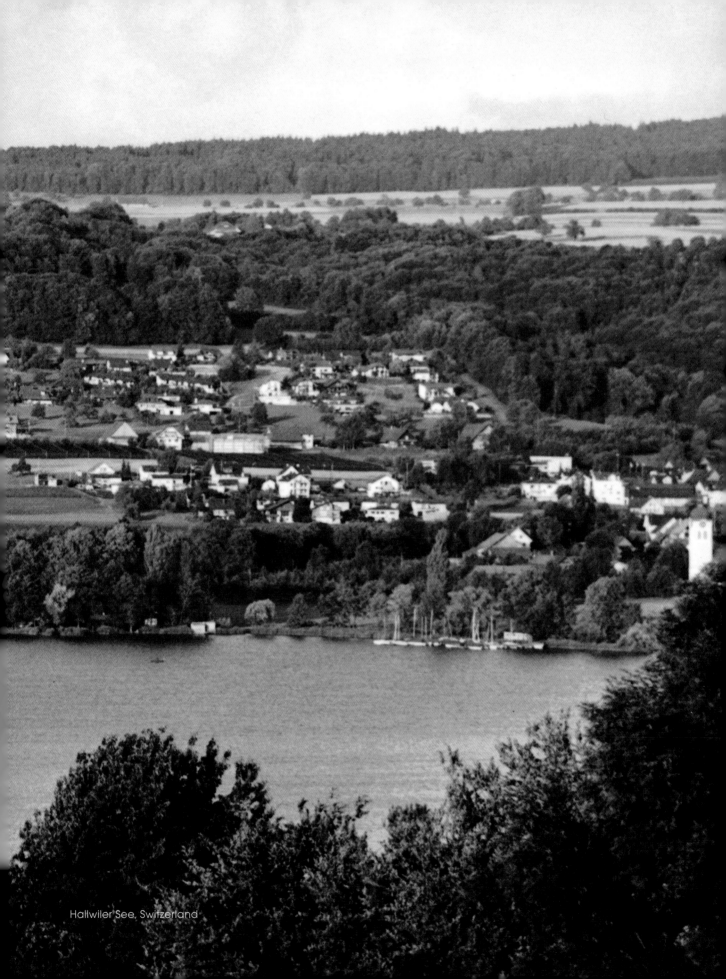

Hallwiler See, Switzerland

S "Hello, I am a friend of Tobias. Is he there?"

"No, but he will be in about eight hours."

or, "Hello, you must be Stephen... I'm his sister Christine, I have a number for you. Tobi says he'll be there for the next two hours only."

T My mother picks me up at the airport in Zurich when I arrive. I'm so happy to see her after nearly eight months, and this is the first chance I've had to be with her again. She pushes an old man in his wheelchair. This is my new job.

We drive across the wealthy city of Zurich. *La vie en Suisse.* Everything is so clean you could eat off the street. We finally stop. Our destination: an elderly care home where the man lives in a small flat. Everything in his space is well organized, as it is all over Switzerland. Clean, quiet, modern and neutral, not for people who are used to living in warm, cozy homes. On the floor lays a

mattress from a sun bed, with a blanket thrown on top. This is where my mother has been sleeping; it is where I will now sleep. The furniture is quite fifties. My mother speaks fast, to the point, as usual. She shows me the terrace with its bland view of the other flats and the man's room. Peering inside the bathroom I think, I hate bathrooms without windows. After my mother explains my duties to me she takes the old man to his bed. We drink a fast cup of coffee together and she leaves for her own home in the countryside. She hasn't had a day to herself in two months, poor woman, and she deserves one.

I'm standing in the room, alone. This is then my new home, for now, where I will work non-stop the next couple of weeks. Twenty-four hours a day. No time for dreams.

I put my luggage into the wardrobe. I go to the window and look out. Suddenly I hear a cough in the next room. I open the door carefully.

"Sorry, do you want to get up?"

A sulky answer, "No," and he lifts his blanket higher over his head.

I introduce myself again. "My name is Tobias Schweitzer."

Angrily, he answers, "Could you leave me alone, please. I want to sleep. Don't disturb me any longer."

"But I think it's lunchtime for you soon."

"In ten minutes, maybe we can talk about it."

"Okay. I'll prepare everything."

Tobi at his mom's house

My mother has been reducing the old man's drug intake more and more. Since she started working here, she's tried to get him out of his bed, which is quite difficult, as I have just seen. Before she arrived there was a "professional" care service. They had looked after him. As is usual in these cases, more care was taken in looking after his money than for him. To let him sleep is easier than to deal with his irritable moods.

I go back into the other room and think, this is going to be a tough job. During lunch I attempt a conversation again. But he is not interested in talking with me. After lunch he wants to go straight back to bed. He continues sleeping.

After I help him to bed I phone my mother. She tells me the story of his past. He is a German jew who is 91 years old. He lost his family and a factory during the second World War. This happened in the German town Cottbus. He escaped the Holocaust and survived across the border in Switzerland. Later, after the war, he became a Belgian citizen, and he lived there with his wife. After her death he returned to Switzerland. Most of his life he had lived on his own, moving from place to place, country to country. My mom says also that he never talks about his past.

S It's nice to be back in New York. Back to reality. After a few days I get a chance to talk with Tobi. He tells me of the troubles he's having with his new job taking care of this old man.

I can't help but wonder how he does it. A couple of days after I return, the company gets an invitation to go to Zurich to participate in some kind of book conference. I reach Tobi on the phone and somehow we are able to make plans to see each other there the end of August. I say that I'll be in Zurich for work during the week and he suggests I come to his mom's home in the Swiss countryside to spend the weekend. I'm looking forward to seeing him.

Around this time Tobi takes a few days off to move stuff from London to his childhood home of Hergenrath in Belgium. He drives across half of Europe in a few fast days, visiting friends scattered along the way. I notice this travel/movement syndrome as similar between us. Sometimes I too feel like I am a nomad.

Waiting to board a plane bound for Zurich, I am sitting at the airport and I give Tobi a call.

A woman answers the phone with a very strong German accent and says, "Hello, this is Tobias' mother. You are Stephen. Tobias is driving here. He cannot come to the airport to pick you up. I am waiting for him. He must come here to meet me so I can leave, and he takes over my job."

I think to myself, my God, well, I wasn't expecting that. But I apologize and tell her I was just calling to say "hello".

My flight is delayed an hour, but I get to the hotel finally and dial up the same number, hoping Tobi will pick up this time. He does, and we talk for a while, hanging up with a week to wait before we can meet again.

I go to work. It's a kind of conference for independent creative companies. I represent an example of a publishing company which deals mainly with visual art projects. I have to do lectures and press meetings. At the TV presentation, I do think it is an exciting job for the company to take on, this week-long project in Zurich. I'm excited to introduce my colleagues to Tobi. But then I realize that I can't really see him because he's working the whole day, and that a 24 hour job means 24 hours, and no free time left over.

A few days later, my work is over and the weekend lies ahead. Tobias picks me up at the hotel with an old man in the car. I don't know what to say to this man. The reality of Tobi's job is hitting me. He really lives in another world right now. We drive an hour to Beinwil am See, between the cities of Zurich and Luzern, to his mother's house in the country. We get to stay here for a couple of days. Here I finally meet the woman whose voice was on the other end of the phone. She is much nicer than she had sounded then. The house sits near a lake, and I can't get over how it is a perfect storybook house, with cows right at the front door and an incredible picturesque view. Postcard friendly. There are plants and flowers everywhere and I picture Tobi here as a young boy, growing up and spending hours talking with his mom about a new sprout in the garden, and I understand a little more about how someone could come from this way of life and naturally grow up a landscape gardener. Right now, I realize, he's with the two things he nurtures: older people, and nature. At one point, a group of us are chatting in the garden with Tobi's mom and he pokes his head out of the very small attic window above us. With cowbells in the background, I think this whole scene is unreal. The party boy from Berlin comes home. I'm happy to be here, to discover a strange wholesome comfort so different and far from my own home. I also realize how long it's been since I've been surrounded by a real family, in a real home. After lunch we run down the hill and jump into the lake Hallwiler See. Funny, that this is the second time I've done this in my life. Both times with and because of Tobi. While we're here, a friend snaps the picture that is now on the cover of this book.

The next day, we take a drive down to Lugano and the Lago Maggiore, crossing over the Alps on the way. Tobi has so much to say about all these

places; these beautiful, extreme locations have all existed as scenes and backdrops for various moments in his life.

At one quiet point over the weekend, he shows me his early landscape work. He has photo-binders of everything: A collection of gardens he has helped to plan and create with his company in Berlin, exercises he had in school, and hundreds of pictures of plants and places he's seen throughout his life. There was very little distinction made between the gardens he had created and the scenes he had come across by chance. These experiences were so similar to him that they seemed fused into one combined idea of inspiration, imagination, and realization. The older photos to which he had given childish names like, sleeping waterpail, staircase runs around the corner and the human tree were favorites of mine. I could really believe, looking at his pictures and hearing him talk about them, that he sees those things in nature, and that to him all life is a kind of fairy tale. I thought of my own childish imagination. And that was when I first sensed our connection through pictures, images. The tangible, held moments in our lives. These photographs of Tobi's actually tell the story of his own life and being, and by looking at his pictures and listening to the stories of his so-far-lived life, I do something that I seldom do. I think about my own past, and begin to remember a forgotten world inside myself.

T Back to work in Zurich I continue my life with Mr. Ladewig. We start to take drives together to the Zurichhorn, a beautiful overlook at the Zurich lake. A wonderful, melancholic summer begins. Mr. Ladewig starts to trust me more and more, and he seems to gain a new, somber strength. I see a certain glow in him, sad but bright, and very slowly and carefully we become friends. Now nearly every day we go to the lake. He sits in his wheelchair, close beside me. Most of the time we stay looking over the lake until sunset.

This summer is wonderful here in Switzerland. Everybody enjoys swimming, flirting, relaxing. My past contained these things, a certain ease in existence. Today is a time of waiting for something, a time for patience. Mr. Ladewig knows that he has reached the last chapter of his life and I wonder what the story of my life in the end will contain. As the summer moves ahead we continue to drive almost daily to the lake, where we sit together and watch the water, the sky, the time passing. I stay on the grass near his chair, never asking if he minds if I jump into the lake, because I know he cannot follow me.

I promise Mr. Ladewig I'll stay until he is gone. But this promise does not come true. The lawyer who cares for his finances won't accept me as his guardian because I cannot get a work permit as a German here in

Switzerland. My mom can't do this job on her own. I want to stay, but I have to go. I try everything I can think of, but the lawyer, with his respect for laws, official papers, and money, doesn't seem to care about my wishes or the old man's. In a long letter I try to explain to the lawyer why it would be important for Mr. Ladewig and me to stay together; that we had each found a friend in the other, and that he didn't have much time left. It seemed so obvious to me, the importance of having caring human contact not just throughout one's life and while one is young, but also at the end... I told him he could pay me less money if that was his reason for saying no. I asked him to compare his system of laws with the importance of this human life, but the personal meeting changed nothing. I have to accept that someone else will look after him, and I leave Switzerland at the end of September.

We had both lost. I have no idea what my future holds. Many doors seem closed to me now, and I don't know where to go from here.

Ten days after I leave Mr. Ladewig dies. I think he had noticed my absence as I had noticed his. Now he waits on the other side of the lake. And I had promised him...

Black and white landscape

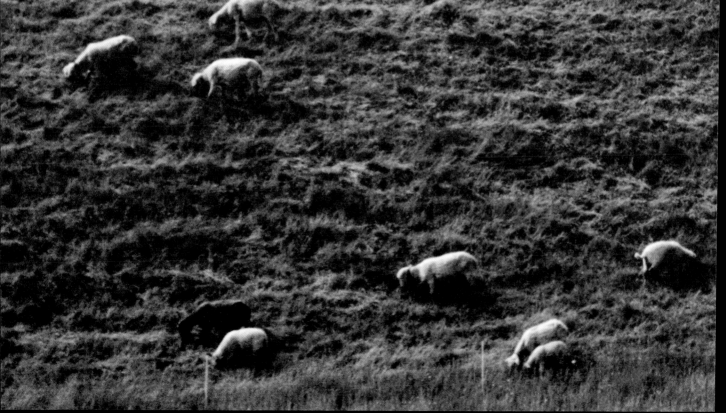

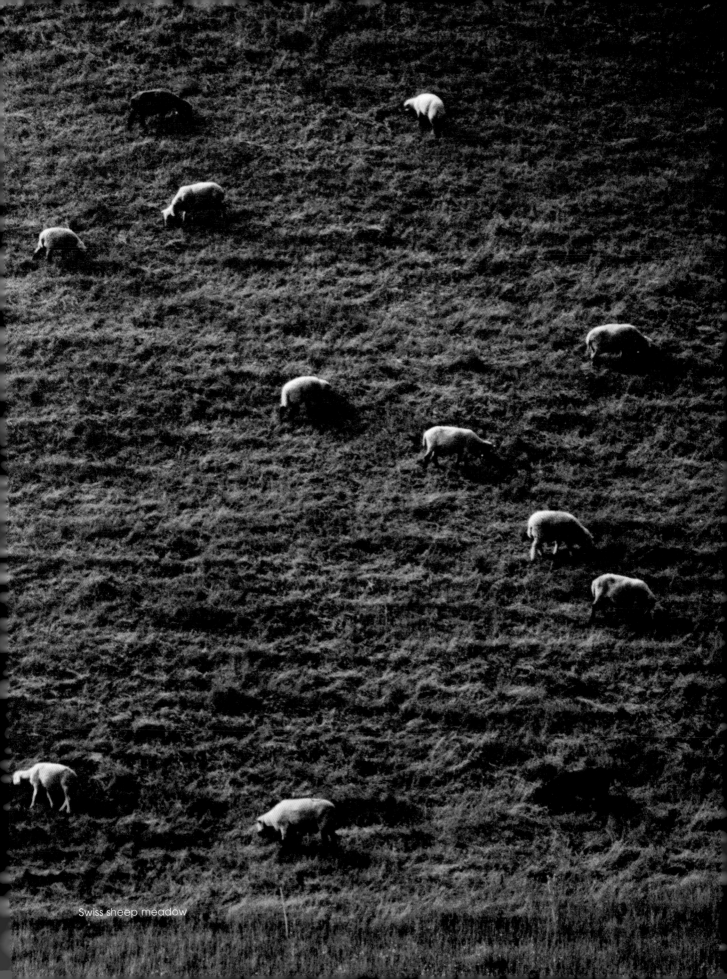
Swiss sheep meadow

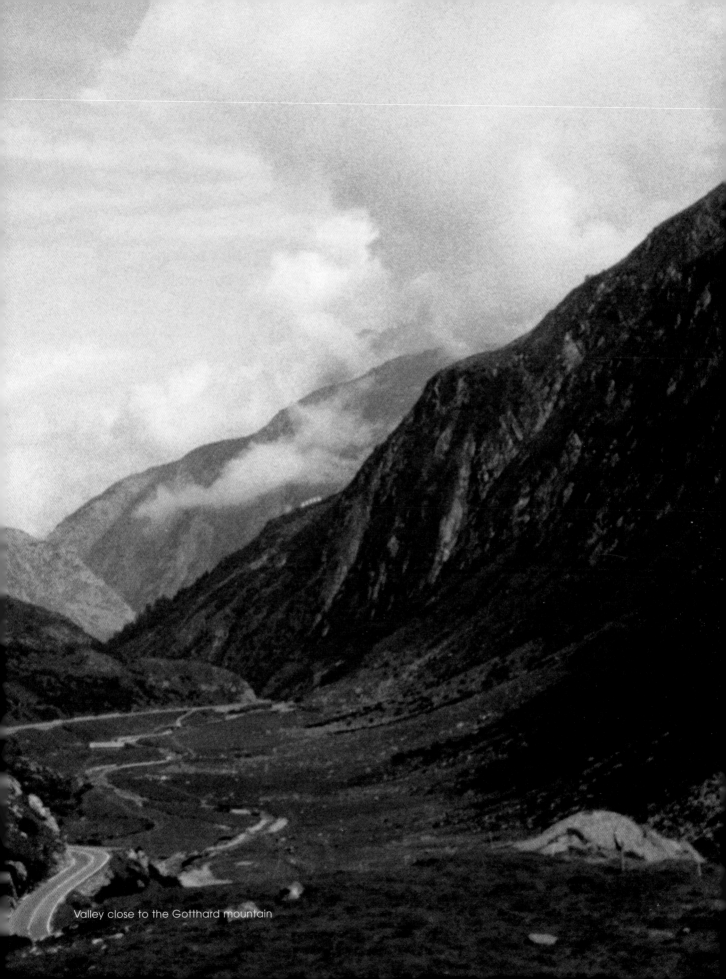

Valley close to the Gotthard mountain

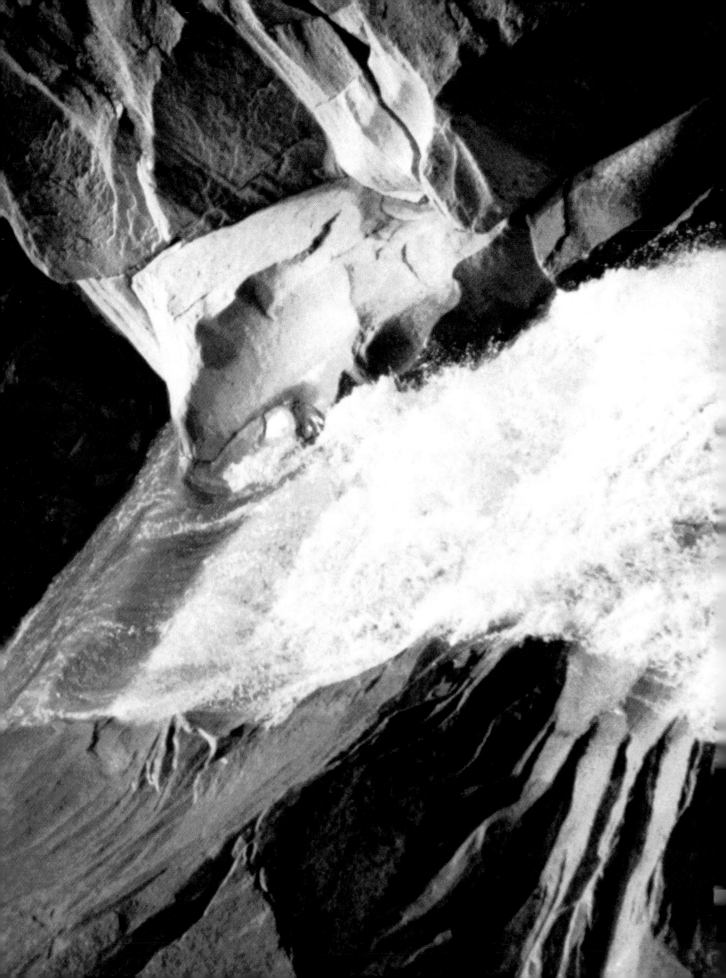

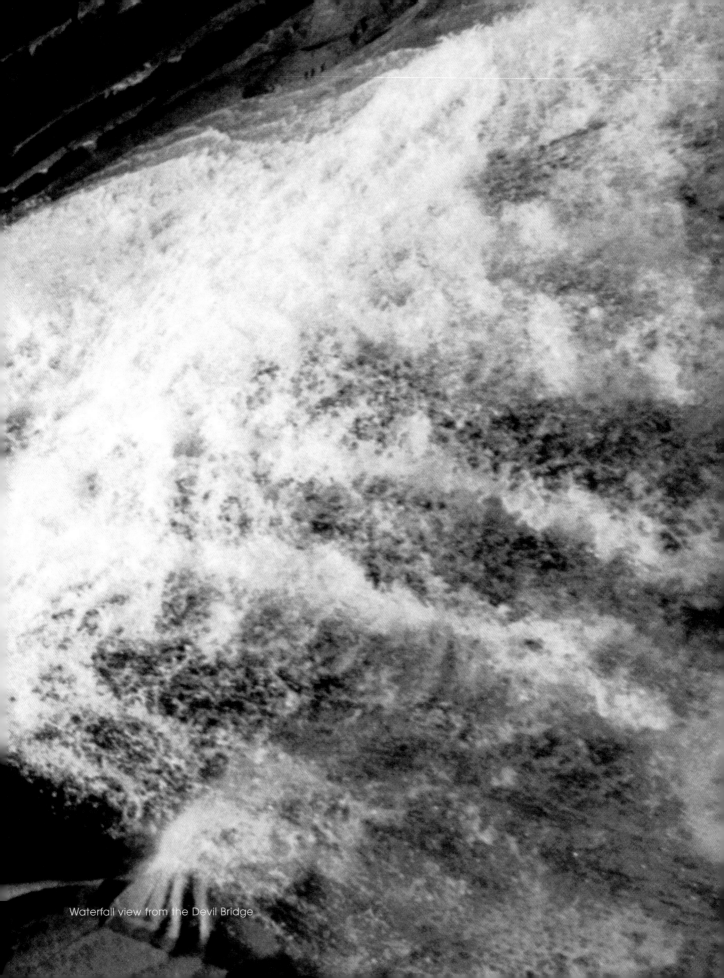
Waterfall view from the Devil Bridge

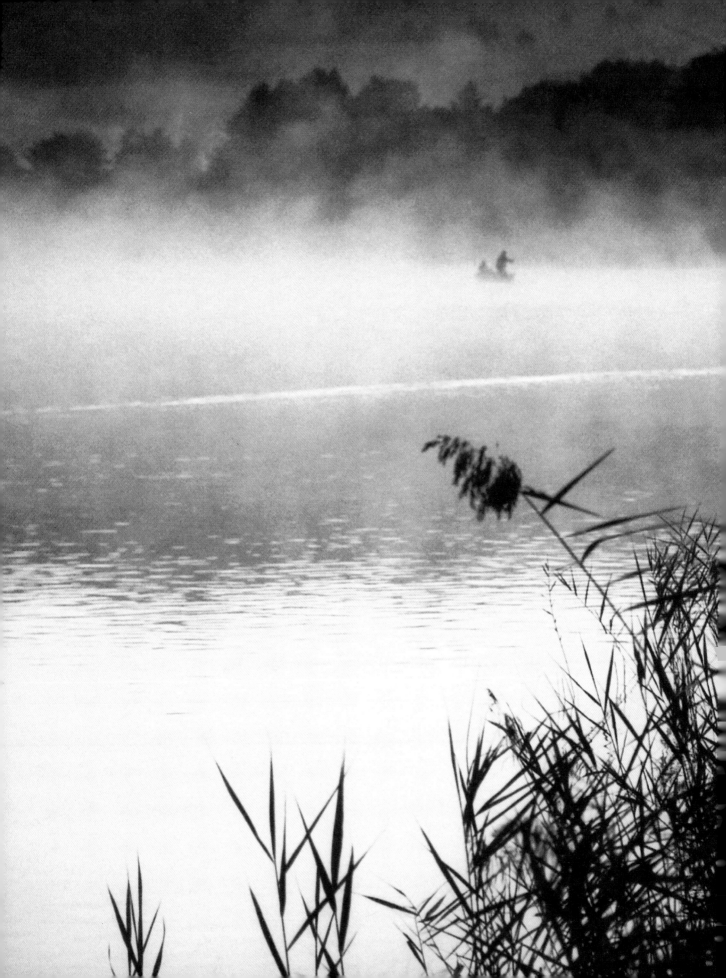

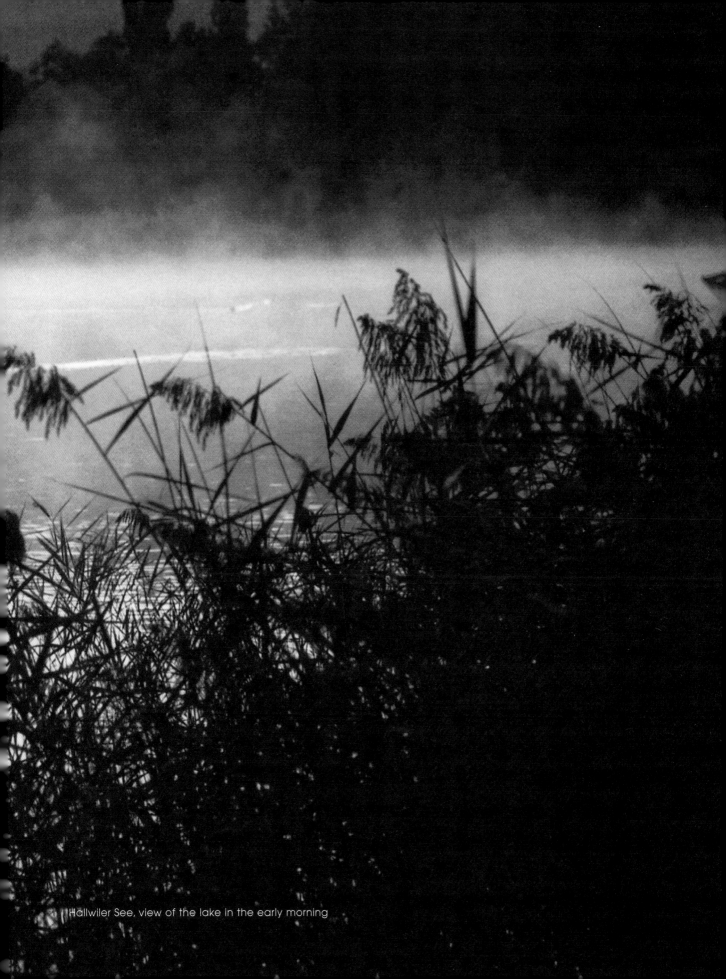

Hallwiler See, view of the lake in the early morning

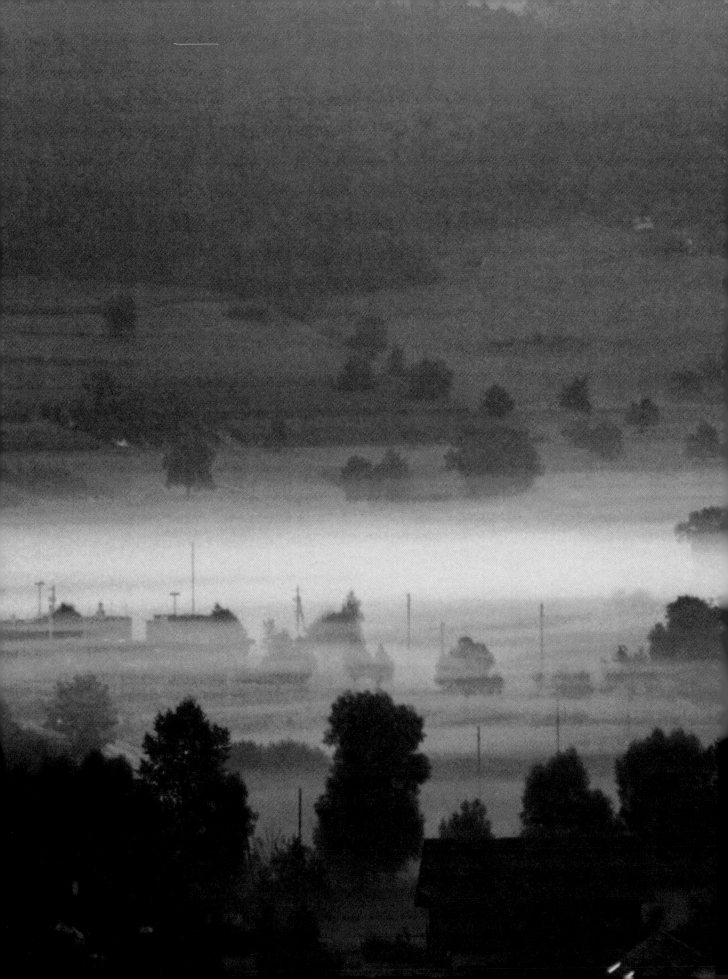

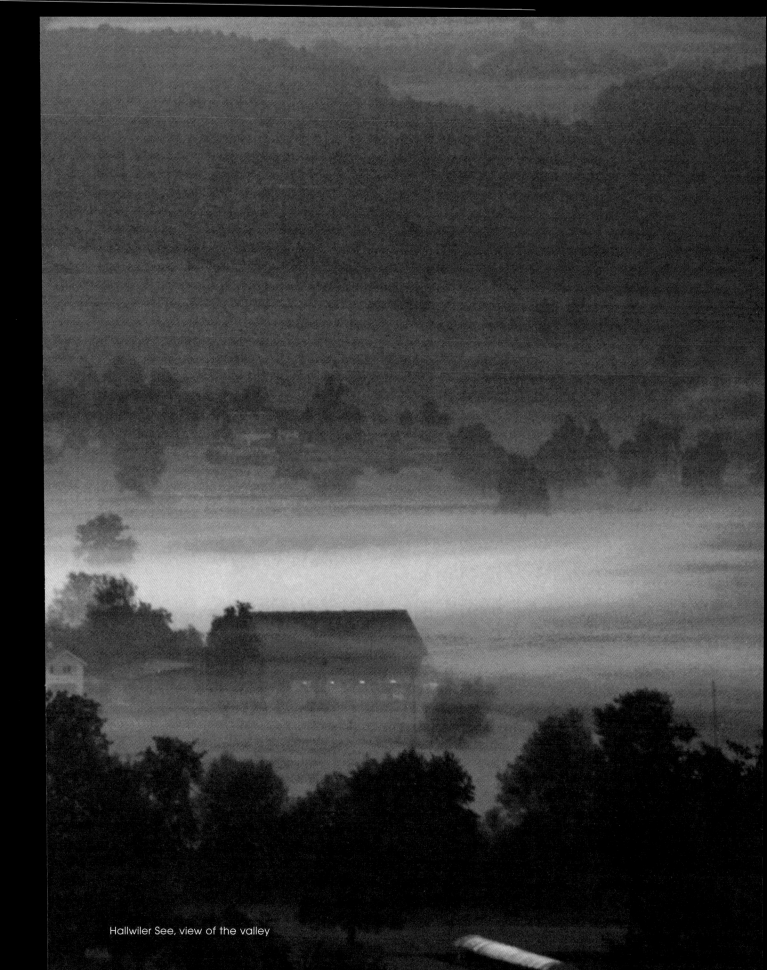

Hallwiler See, view of the valley

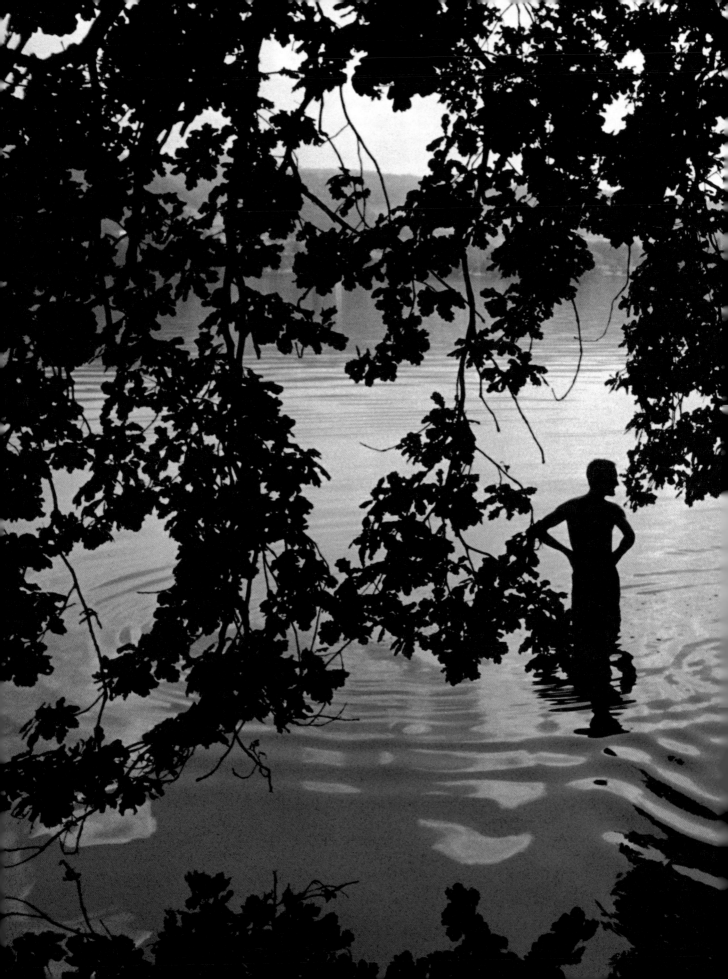

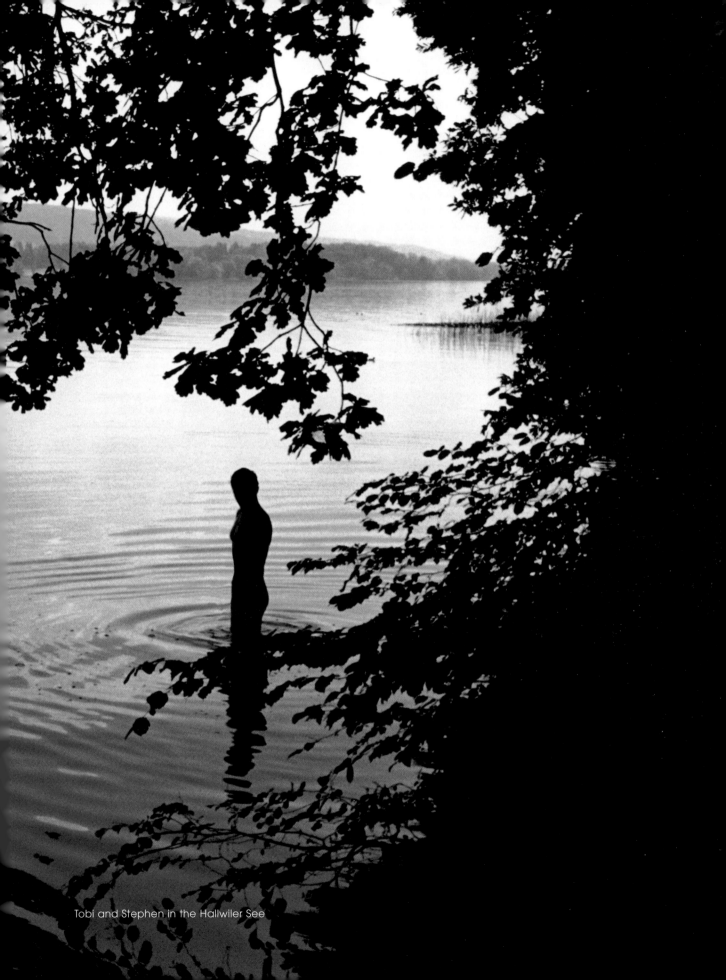

Tobi and Stephen in the Hallwiler See

paris

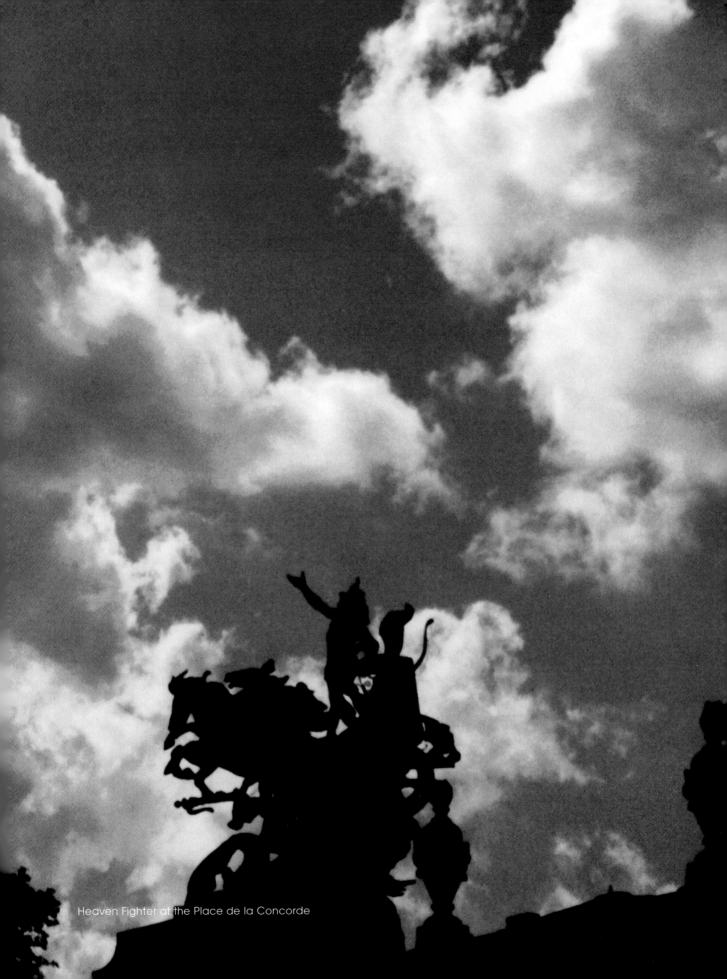

Heaven Fighter at the Place de la Concorde

S I learn that I'll be in Paris, not New York, during Tobi's birthday, so I invite him there to celebrate with me.

Arriving on the third of September, I look forward to showing Tobi my favorite Parisian places, when I find I am needed back at the photo shoot. Does work have to intervene on this of all days? Again I have to adapt to one of life's not-so-funny tricks, but what an unfortunate card to draw today. I had wanted so much just to have some quiet time with Tobi, but we go straight to the studio instead. We stop on the way for a quick cup of coffee with one of my oldest friends, Hedi, and I'm glad he is able to meet Tobi, even if only for five minutes. I want to enjoy the day, I want it to be mine, and I stubbornly wish I did not have to be stuck indoors. It's early September in Paris and going inside seems like "back-to-school." When Tobi accompanies me to the studio and then leaves me there, I truly feel like a child brought to class for the first day. He disappears after just one minute, his Walkman fixed on his head. He is unimpressed with fashion shoots and prefers to be outdoors with trees and movement, not inside with models and artificial lighting. How can I blame him? I wish I could play in his world too.

T I stay with Stephen only moments at the studio. This is the first time I see him at his work, but the weather is too beautiful for me to stay inside. I step out into a bright sunny day and discover the late summer of Paris on my own. The sky is bright blue, the air fresh and cool and filled with the sounds of people moving. I cross the Place des Vosges, the great 17th-century square, and watch people chatting, young children riding their bicycles, and tourists starting their holiday hunts.

I switch on my music and begin to really relax. The calm sounds are perfect for this day, and my soul moves lightly in this wonderful morning. Time seems to slow with the rhythm inside my head, and I start to run with the power of the day. I pass streets and squares at first slowly, and then faster and faster without any known direction. Through my dreamy run, a movie of sorts begins, fast like flight I pass through this place, past these people, each greeting Paris in their own way. I feel free. I run and run, all the time with the stream of sound compelling me forward. The air is cold and my lungs start to feel it. My body feels good, as if I am inside my skin for the first time in a long while. The rhythm quiets, I slow to a walk, and my inner film slows as well.

I miss London. I miss Berlin. I miss Hergenrath. In other places I visit, I am a stranger in these different worlds, always in a sort of dreamland.

All around me are people enjoying their lives, today: a woman reading to

Light house, Place de Vosges

herself on a bench; an old Chinese man studying plant names in the park; a German couple looking at art installations on the Champs Elysees; two young people walking together, enjoying each other's company; and children running across my path. Existing as a part of all this beauty, inside this stream of aliveness, I miss my companion.

I become aware of the changing light, and start to run again. It is my good old friend *light* saying hello, the light that I've embraced thousands of times in my gardening past, the meeting of sun and shadow. Each is independent, and each celebrates friendship with the other. They enjoy their rendezvous, and I am just a visiting presence. I see, now, glints of cool brilliance crossing glass roofs and smashing against walls. A garden truck flashes orange light along the length of the park. Sun reflects upon grass seeds, and a puddle shimmers to reflect the light of the sky. Long shadows stretch the forms of people sitting or standing. A smooth wind keeps them dancing. It is a living moment, a profound moment for me here in late summer in Paris. All around me light dances, and what wonderful pictures it creates. I'm happy, but I do wish Stephen could be a part of this day.

S Night falls and we are expected at the Palais Garnier, the old opera house, for a celebration to launch the latest issue of the publication I work for...

T When we enter the opera house, I have to stop and look around me in disbelief. This place is like a baroque palace. We arrive quite early, and Stephen is excited to give me a tour of this amazing palace-like place. I can't stop staring at the reflection the lights from the discoball create, like a snowstorm lightshow... Stephen and I keep running up and down the huge staircase, to the melodious rhythm of the music.

S Even while we are here, I know I'll never forget dancing at the opera... with its grand staircase, illuminated like the night sky with countless stars reflected from mirrors on a massive mirrored ball, spinning over the partygoers. One image in particular is burned forever onto my memory: the cavernous ceiling vaulting over the dancers lit like a man-made vision of heaven with the colors of hell.

Stephen and Tobi, Hedi's apartment

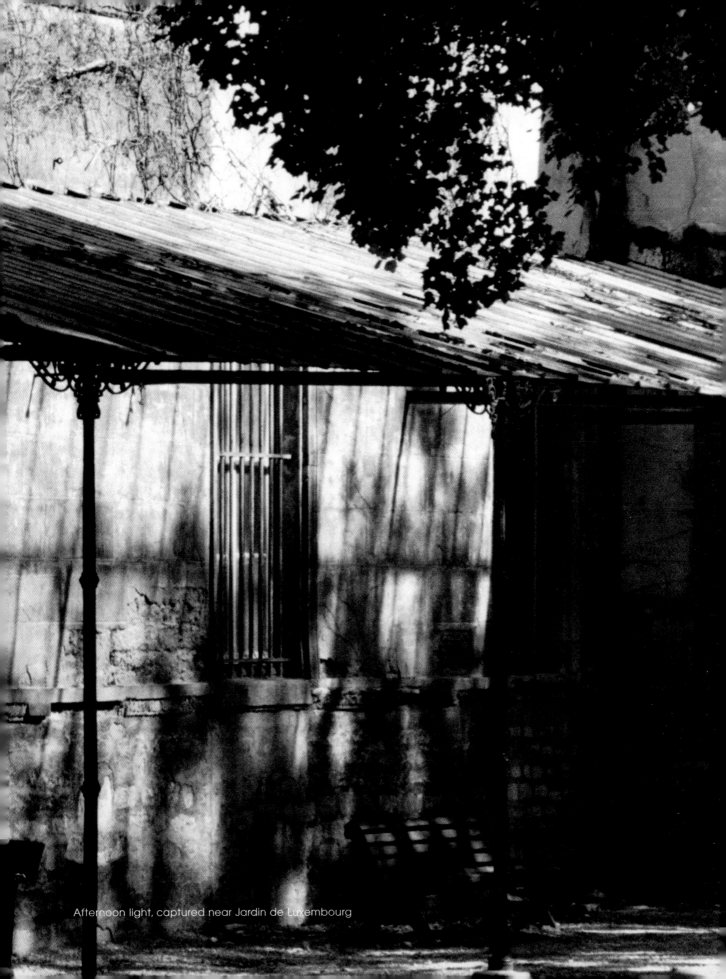

Afternoon light, captured near Jardin de Luxembourg

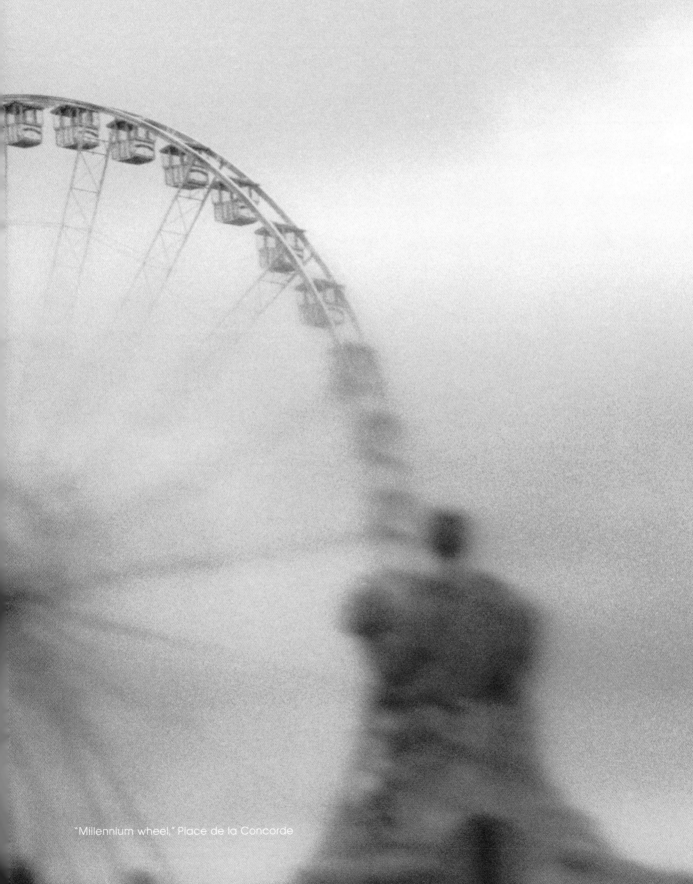

"Millennium wheel," Place de la Concorde

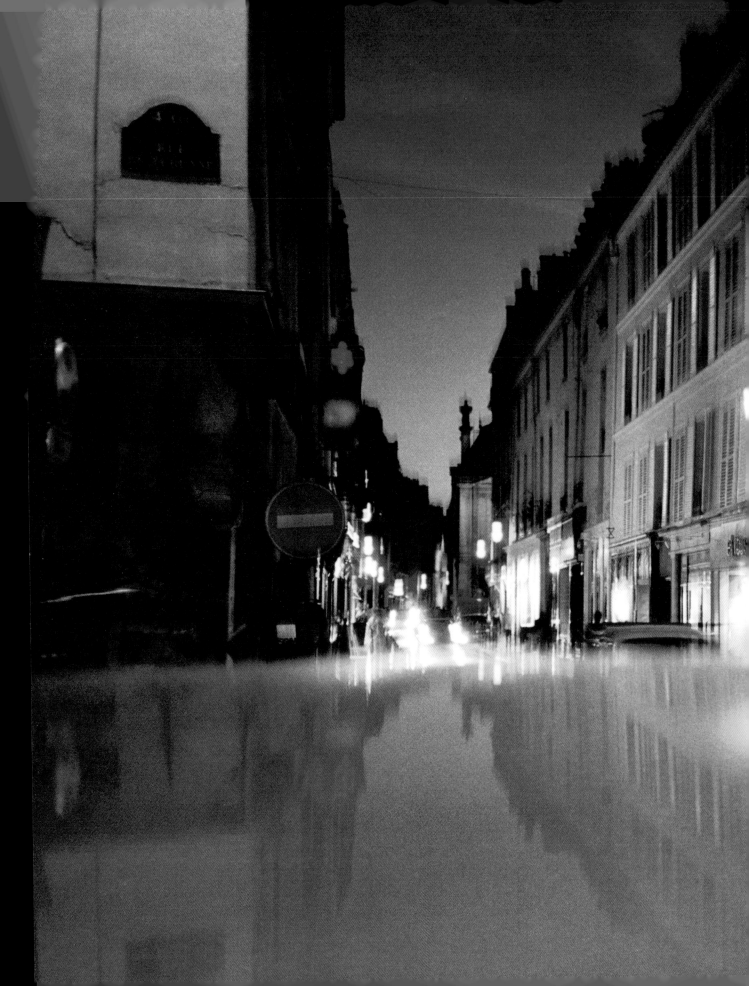

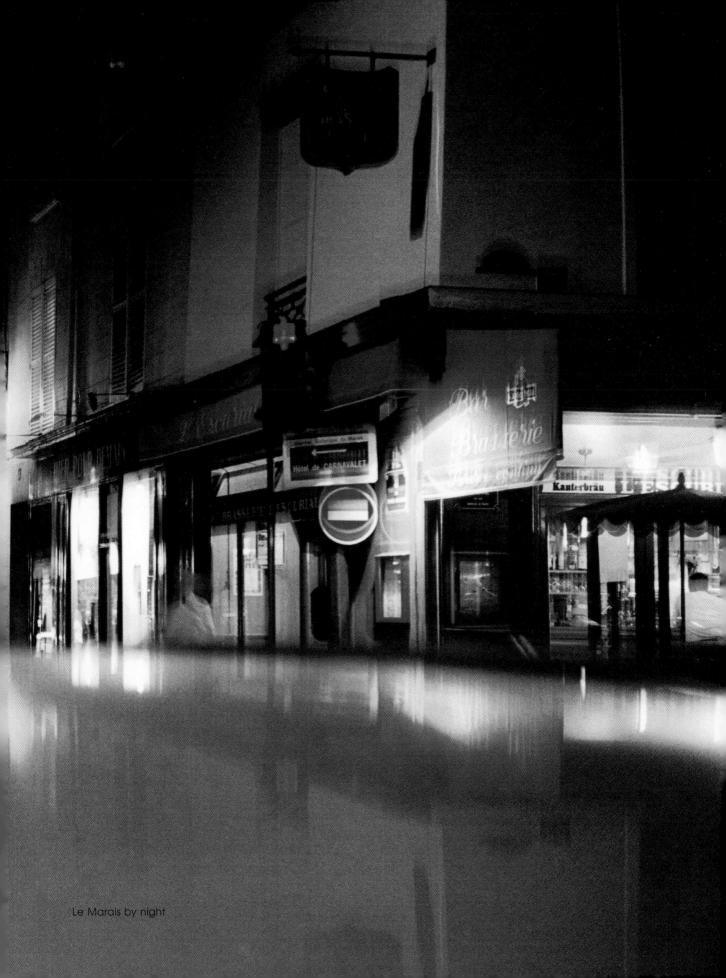

Le Marais by night

Mouvement de parisienne

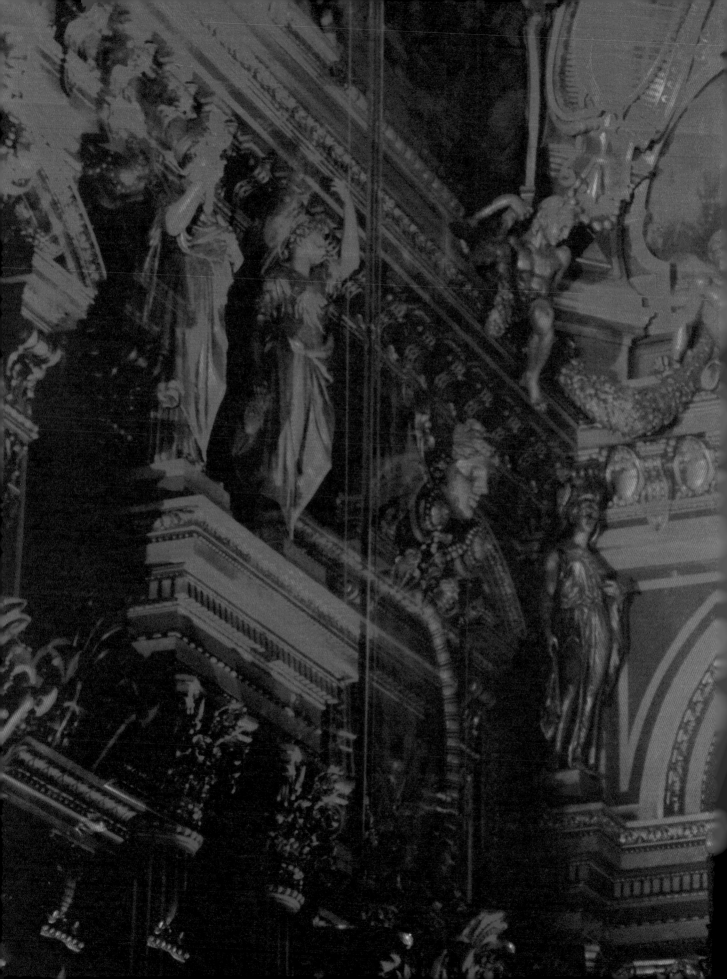

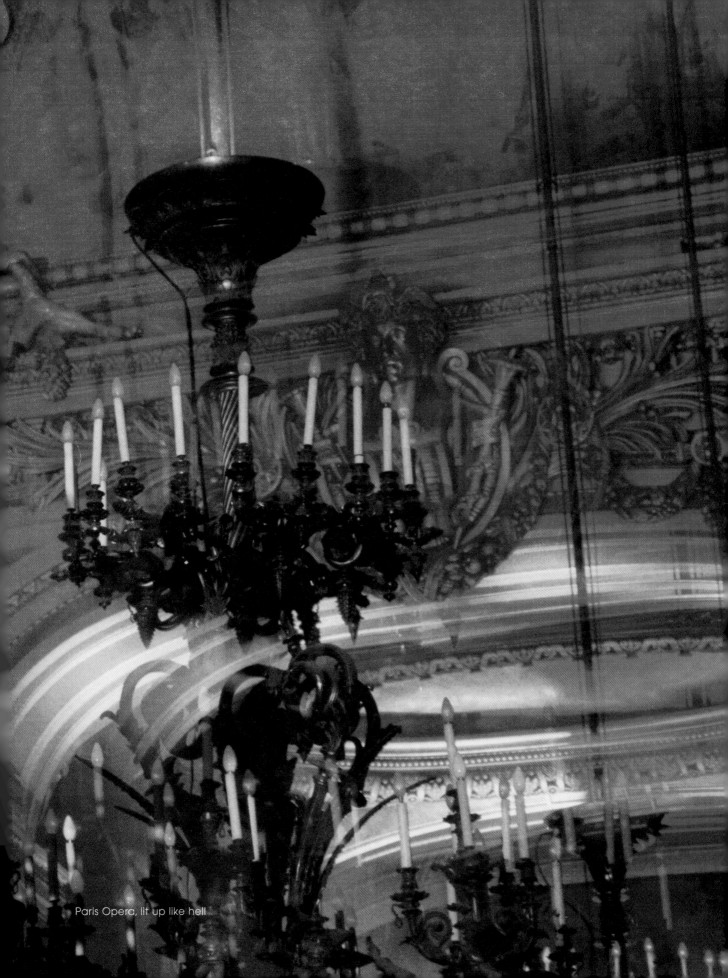

Paris Opera, lit up like hell

hergenrath

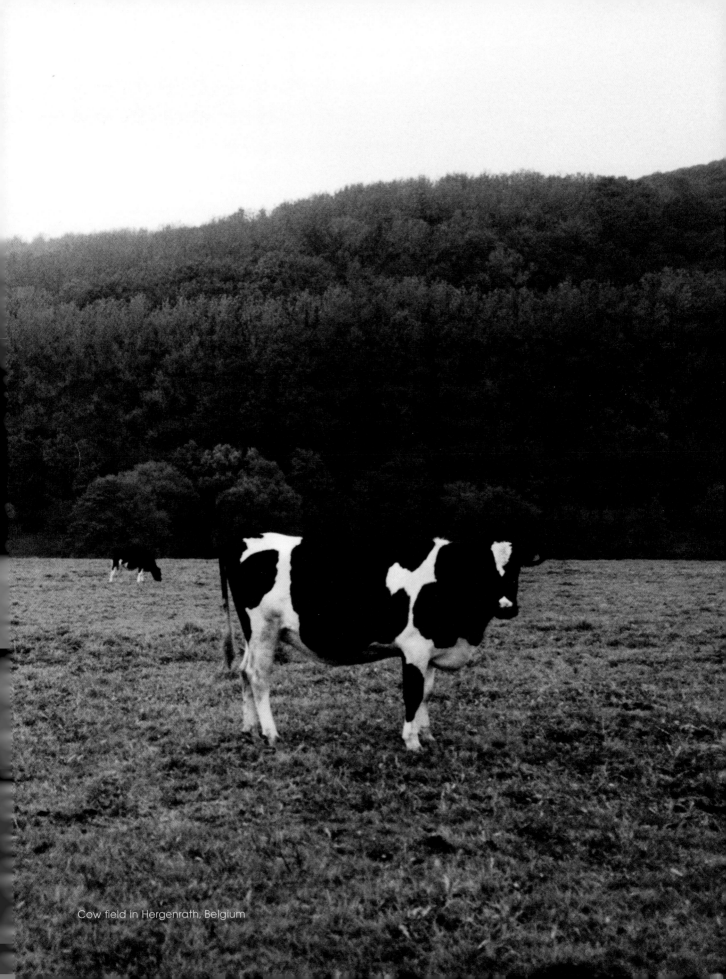

Cow field in Hergenrath, Belgium

S We leave Paris and take a rainy drive in Tobi's car to Hergenrath, where his sister has a home. Hergenrath, on the border of Belgium and Germany... the countryside, a sweet house. I notice right away how all of the houses look like barns, with their weathered-gray wood and simple construction.

I give Mario a call: "Mario, I wish you could see me now. I'm standing in the backyard of Christine's house, and I don't see cows, but I'm sure they're all around. And from the looks of the ground, I think there are chickens too..."

It's raining, and I'm sure it often is around here. Rain seems to fit with the whole atmosphere. I find it funny that Tobi says, "Look at that house a few blocks away. Now we are in Belgium, and when we cross this street, we'll stand where I grew up, in Germany..."

One night we take a drive through the forest. Every now and then Tobi steps out of the car and moves branches that are blocking the path. I have a thought then that this must be common practice when you drive through forests, which then seems a stupid thought. All of this is so different from anything I have ever experienced.

We get out of the car at one point. It is completely dark, and Tobi is leading me by the hand. I have never walked through a forest at night, and I find it creepy. I wish he had left the headlights on so we'd know where we were walking. I may as well be walking blindfolded. You can hear the ripples from a nearby brook, and I hope Tobi doesn't get the sudden urge to swim. This is crazy, isn't it? One night I'm dancing at the Opera, the next I'm walking through a pitch-black forest. One night is brightly incandescent with a colorful, star-filled sky and the disco ball for a moon. The next day I'm walking blind in a dark forest, I have no idea where I am, with no sight and virtually no sound, and only a hand to guide me. Tobi keeps telling me strange things. "Look at the small pond; look at the old house." I can hardly see a thing. To me, everything lies in soft black, shadows too thick to see through. Tobi seems to see at night, like a bat. Tonight, I am like a child. I give in to the dark. I just follow, go with the flow. No sight. No sound. Just follow the hand that leads me...

The next day we visit the house where Tobi grew up. His father still lives here. It's in Germany just across the border. It is like autumn: chilly, drizzly, and grey, the way you imagine the weather when you are being shown the past. But I also imagine, then, this place in the spring and summer, when things are in full bloom, and I think of Tobi when he was younger, experiencing these brighter moments. Right behind the house is a small forest, and the site where his beloved treehouse once stood. Here there was also, once, a pond.

Path leading to Hergenrath forest

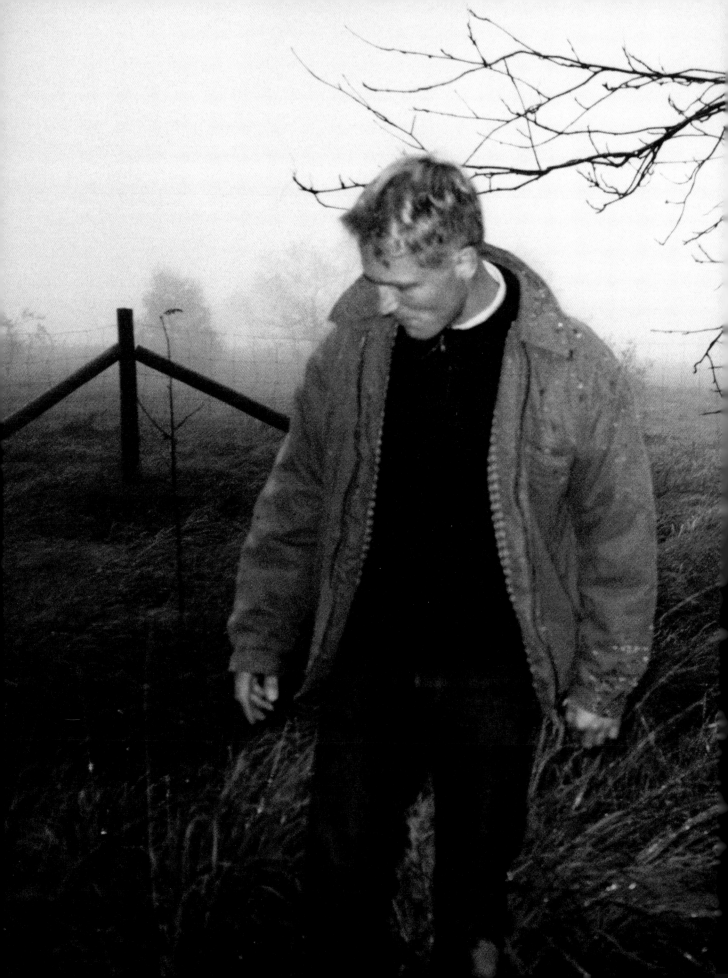

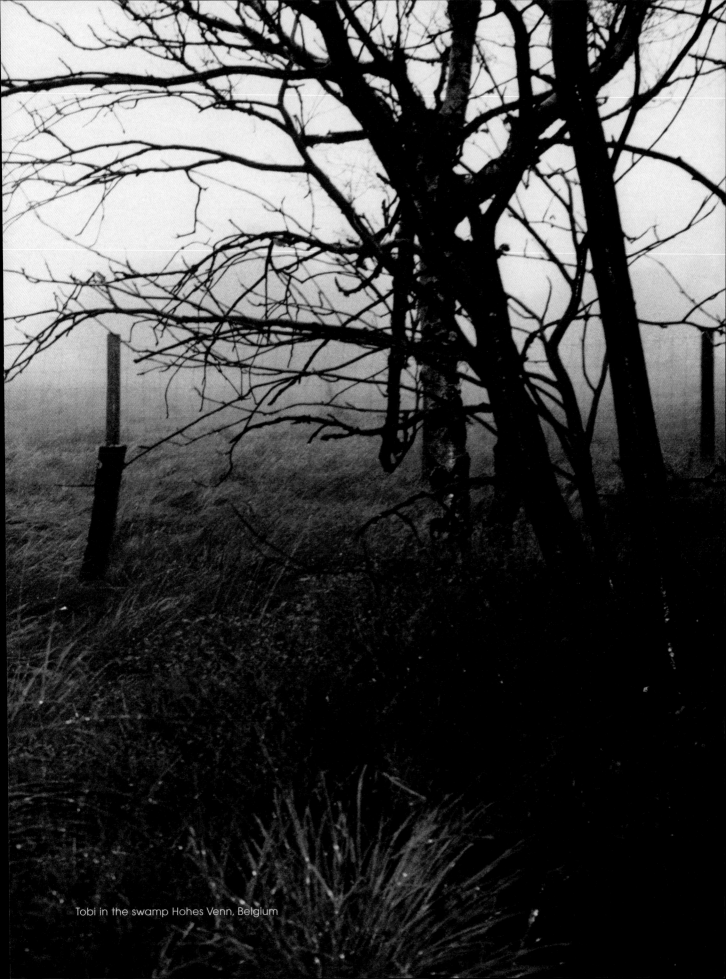

Tobi in the swamp Hohes Venn, Belgium

We cross the stream on a little bridge, and I think about Tobi just running into the forest every time he wanted to run away. I have a favorite picture of Tobi from this visit. He is standing with his forest in the background, and he fits perfectly in this place.

It is on this trip into Tobi's world that I really begin to understood the role that nature plays in his life. Every forest is an enchanted forest he can escape to. I am happy to go, and explore this new world, as long as he is there to lead me.

A few days later, Tobi drives me back to Paris. We were hoping the car would make it, and it did. We have twenty-four hours there and then he has to drive back to Hergenrath. I don't know when we will see each other again. I don't know where it will be. I know that he has to go somewhere and find new work. Many months later, I find a picture of me he took right before he drove out of the city. I have this blank look on my face that seems to say, "What now?"

Dear Stephen, *Autumn in Belgium*

A walk in the forest of Hergenrath
I close the door behind me.

I have to take a walk. I feel lonely and lost. It's a common thing to feel lonely. My father does, by waiting for his second wife. He has been doing that for three years. My mother has, by working 24 hours per day, week after week, caring for old people. My best friend does the same by waiting for someone to share time with. Often, because of this waiting, they are stuck in their lives. Yes, I got lonely after losing the right to live in Berlin, and the same feeling came when I was unable to stay with my older friend in Zurich. And today I wait for a chance to carry on with something, somewhere that feels like me. Nobody is free of declaring himself lonely. Maybe you feel the same.

Today I spoke to different people by phone. The weather was bad, and everyone I talked to felt lost in his world. It seems that only very old people sometimes get used to that.

I walk for a while on the path into the forest of Belgium. I brush the leaves at my sides with each step. It's nice to smell, taste almost, the autumn leaves. Yes, also here thousands of miles away from where you are, we have autumn.

I ask myself often, "Where is my place?" Home for me is everywhere and nowhere. Wherever I go there are friends who welcome me when I come.

Tobi's treehouse, 1985 Treehouse site, today

Everywhere I have lived I have felt some sense of home. There was a home for me in Berlin. There is this home Hergenrath, where I am today. These homes mean family. But before the people who I consider family became this, we had believed together in something. We had shared an element of life together. There was the dream of this Belgian house, which is today the home of my sisters. There is the small landscape company, which my friends Birgit and Wolf still believe in. Now, I have so many places I can call home, but I am always leaving, and I wonder if there exists somewhere a home that is mine.

It starts to rain. I get to the top of this small hill; I can look down from here into the valley where I lived in my childhood. There at the left end I can see the house of my father, where I grew up. Further up where the small forest meets the field is where my tree house once was. It lived there for ten years. There, also, I kissed the first time. Today, I can only see the trees moving in the autumn wind where the treehouse stood. Often I have asked myself, wandering backwards into memory, what all happened there during that innocent time. My friends and I as children, making fire on the ground, falling in love, running from each other in the trees. I remember a bathtub we dug into the ground to make a pool, where lots of frogs and a big fish we named Karlchen lived. Later, the fish was eaten by a tall bird. I don't know the name in English.

I turn back into the forest, on my way home. I think Lulu and Christine are waiting for me, with dinner.

The wind starts up again and I can see the clouds ahead and above me, coming closer. I close my jacket. The last sunlight stretches thin over the fields. One house in sight with its broken roof looks as tired as I in this late day. Through everything I've lost I feel, now, that I've somehow found a way through this loss and emptiness to a part of myself very deep inside. Sort of a return journey. I feel clear, and ready to start again, no matter the form my next challenges come in, no matter the place. Standing here in the rain, I think about you far west at the other side of this ocean. And I know you think about me. In and near Berlin lives the "continental forest," meaning the weather comes from Russia. The forest where I am today is called the "oceanic forest". The raindrops come from the west. West where the ocean

Belgian farm house

is. West where you are. When I feel this rain dropping on my face I feel the rain which your land sends me. This rain which helps new tree house trunks to grow, for new children's dreams. I feel close to you.

It starts to rain harder. I stop for a moment under a big tree, a *Fagus sylvatica*, about 300 years old I am guessing by its size. It was planted during the time of Napoleon, who had decided to own the world. At least he left behind some nice trees when his reign came to an end. These trees, a long line of them, created the border, long ago, between Germany and France. Today there is no longer any real, distinct border, only these very old trees which still stand. Today, this is only a forest in Europe between two united countries. The living line is a mark of a previous division.

I have decided to be with you. Our worlds today are divided into two separate lives. I want to share with you many things, but today we have to handle the separation. I believe it is possible that the borders which divide our lives today may become senseless and unnecessary. Maybe in a year, maybe in many years. I don't know when the time will come that I'll feel free again. Now, on this short walk with myself and your raindrops I feel free, I know that you think about me, and I miss you.

Your Tobi

S A few weeks later Tobi calls me and tells me he's accepted a job offer from his brother to work on the grounds and construction of a resort in the mountains of Turkey for about seven months. He seems so smug, and so content with things. As if he's been sent off to war and that's that, that is the way things are. Turkey. No, not Istanbul, but somewhere in the mountains of a place called Alanya. Alone all these coming months, working on a building site. How can I question things when Tobi himself always seems so content with the way things are. I ask myself once again, "What now?"

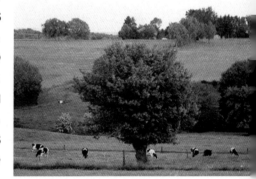

Belgian countryside

Cow shelter under the trees

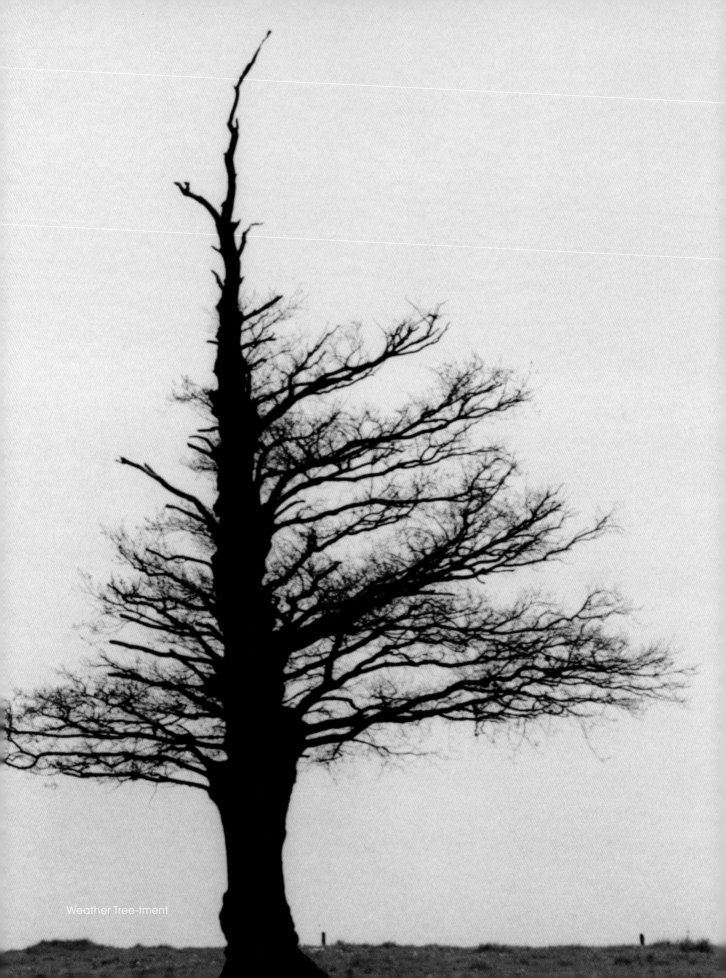

Weather Tree-tment

Raindrops on kitchen window, Tobi's sister's home

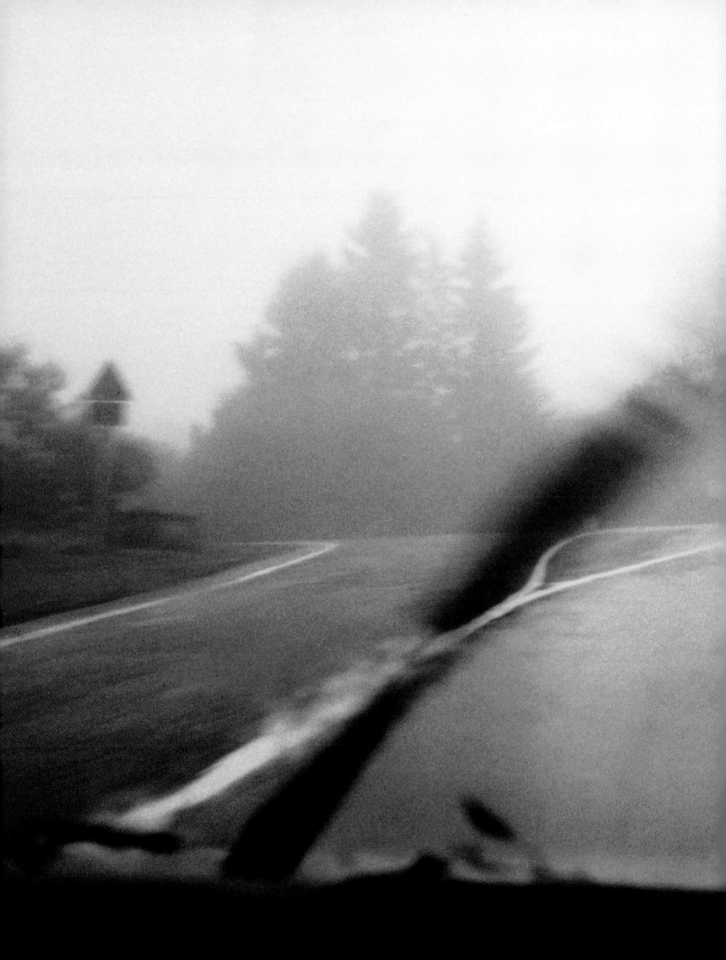

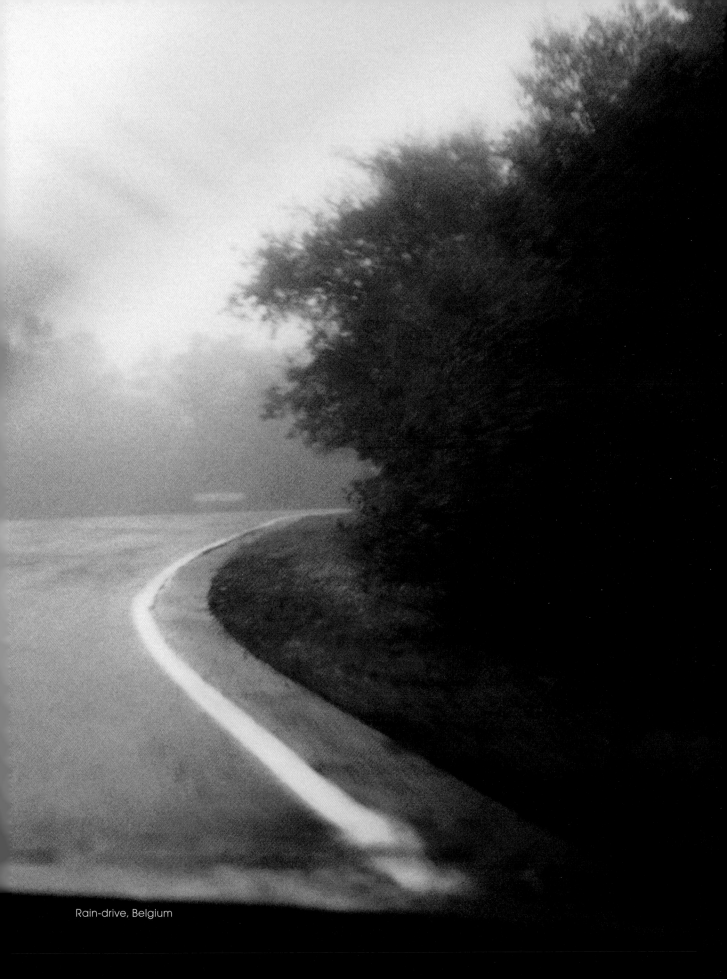

Rain-drive, Belgium

Night walk through the woods

stolen moments

LOS ANGELES

S For months now Tobi and I have not seen each other, speaking only occasionally when telephone lines in his region of Turkey are functioning. In the midst of this limited contact, I surprise Tobi's mom in Los Angeles, where she is caring for another elderly Swiss man who is visiting a Beverly Hills home. I happen to have business in L.A. and directly from the airport I drive to meet her. Apparently she has just arrived, too. When she opens the door to meet me, she reacts as though she might faint, and chokes on a bite of bread, the other half of which she still holds in her hand. She is so pleased to see me that she nearly weeps.

"How is Tobias? How are your pictures? When did you talk with him last in Turkey?" Everything comes in quick succession.

"I have all the pictures with me!"

"Oh, how wonderful! And where will you meet next?"

"We're trying for Hergenrath at Christmas. We'll miss seeing you there." I already know that she will be spending the holidays in Los Angeles working.

We take lots of photographs of just the two of us. And now I carry pictures of Tobi's mom to show Tobi.

HERGENRATH

S Tobi meets me at the Dusseldorf airport. He arrived from Turkey the night before. It's two days before Christmas, and I thank God they honor that holiday in Turkey and we can steal these next days to be together.

I am exhausted from traveling from New York to Los Angeles and back in a few days with plenty of deadlines in between. Then here I've been racing like mad to finish work before the holidays, and as

Tobi's bonfire

excited as I am to see Tobi, I collapse into bed and spend the entire day asleep. When I wake it's nighttime, and outside the bedroom window is an enormous bonfire. Beside it, Tobi waves to me. I put on a coat to meet him, and find an extra chair and a bottle of wine waiting for me outside. The air is bitter cold, and he motions me to come closer to the warming flames, dancing like fireworks in the dark. The countryside is wintry and frozen, and here we are sitting outdoors. It feels so magical to be here.

"What will Christine say when she sees the remains of a huge bonfire in front of her house tomorrow?"

"She'll be angry with me," Tobi replies, as simply as that.

It's good to be here with him.

BERLIN

S A few days later we leave Hergenrath for Berlin and the "Millennium New Year's Eve." Tobi must spend much of his time here running errands (concerning his bankruptcy,) so he has little time for playing in the city. Ultimately we celebrate very little of this holiday. I find myself sitting and waiting at cafes and waiting rooms, and doing mundane, yet necessary tasks like laundry in his former apartment, all things that Tobi needs done in the limited possible time here.

The evening before New Year's Eve, we steal a bit of time for ourselves. The nicest aspect of his high-ceilinged, pre-war apartment is the old tub. He admits now that the tub is illegally installed here in the "living area" of a commercial loft. The tub's location, in front of the curtain-less balcony door, is all the more out of the norm. Snow is falling outside and there are patches of snow on the ground. We enjoy a bath together with dim Christmas lights, a glass of wine each, and quiet music. As we sit in this bathtub, I remember vividly our first time here. Tonight, Tobi is in one of his introspective moods. He begins to describe life and living as a garden, and asks how I would design my path through this garden? He adds that life is like swimming in a lake, and that his dream is to swim in that lake with someone.

"What is it that keeps you going? If you lost everything, what would then remain?" He keeps asking similar questions, but I cannot answer him to his satisfaction.

He tries to explain his question to me in his visual way of describing a thought, and when I understand how deeply important these questions are for him I want to answer as best I can, but I feel useless in these kinds of conversations.

Suddenly he stops talking to me and rises from the tub. He walks straight into his room and closes the door behind him, shutting me out to be alone. I don't know what to do. I saw in his eyes how lonely he feels. I saw his wish to share with someone his fundamental beliefs during what I know to be a difficult period for him. I try to find a way to bring him back to me, but his door remains closed and he's closed his heart as well. I know that he believes I can't understand him, that I don't know his deep sadness, his sense of loneliness and his struggles. But I do. I just don't know what to say or how to tell him. I want to say, "Tobi, I'm just not used to thinking in these terms, much less speaking in these terms. I really am with you, and I'm with you wherever you are, wherever you will be." But I cannot get the words out, and we have only one day left before we part again, this time for many months.

The next day is New Year's Eve, in Germany the celebration is called "Sylvester." This time, an entire century comes to a close, and the next begins. Though Tobi and I manage to make amends during the day, the evening becomes one of the saddest nights of my life.

We take a photo together of the Brandenburg Gate, lit with bright, multicolored lights. Looking at it one thinks how dazzling and festive it appears. Or, rather, that is how it must appear to the thousands of people who see it this night. To me it is a picture of a sad clown. As the fireworks launch at midnight, my heart sinks further... Tomorrow, Tobi will return to Turkey and I will return to New York, and it will be at least four months before we can even consider meeting again.

I feel that his working in Turkey is the worst choice he could have made, and he gives me almost no say in the matter. He acts as if all is fine between us, as if this separation of lives is just life, and that's reality, and that it's all only time anyway. He says this repeatedly, as if this is some consolation.

Within hours, we are again traveling toward the airport. His plane for Alanya leaves very early in the morning, a few minutes before mine. I have long despised waking up before dawn for a flight, but today I loathe it even more than usual. We remain quiet throughout the ride. Finally, seeking to break the silence, I ask him what he is thinking.
"Spring blooms," he says.

I say goodbye and leave a postcard in his bag:

Tobi,
I hope to see you again in the spring, after your work is
finished in Turkey. Yes, I want to swim in the lake with you.
Stephen

Days later I am still disappointed with his choice, regardless of his expla-
nations. He seems so content though, as if he's been drafted into war and
the situation is out of his hands. How am I to question Tobi's choice when he
seems so accepting of the way things are?

As it happens, even though his post is in a relatively accessible area of
Turkey, he is not so easy to reach. The phone connections in Alanya are com-
pletely unreliable. We are limited to one quick phone call per week, and
sometimes not even that. He uses his brother's German mobile phone, and it
works only intermittently. When it does work it costs a fortune no matter who
is calling, so there is frequent silence between us whether we like it or not. I
begin to seriously doubt this imposed lack of communication, and what it
says about us. What it doesn't say is even worse, and were it not for my
intense work schedule right now I'm not sure how I would feel. During the
worst of this period, I receive a letter: two people from my company are invit-
ed to Asia to do research in Beijing, Tokyo and Bangkok. As I read I wonder,
isn't Turkey part of Asia? Wasn't Turkey Europe's gateway to the Orient?
Alanya must be on the way to Beijing, or vice versa, and surely Tobi can make
a short get-away?... Hopefully?

A couple of days later I make a phonecall to Turkey, to ask Tobi what he
thinks about coming with me to Asia for a few days. I dial his mobile, then
realize there's something wrong with his phone. After I had tried a few times
I finally get through. Surprisingly, an Arab voice answers the phone. At first I
think maybe Tobias left it somewhere on the site in order to get in touch with
one of the workers. Something strange is on the other end of the line. I under-
stand about as much as I understood of Tobi's latin plant descriptions: noth-
ing. So I just say, "Could I talk to Tobias?"

The voice answers in very broken English, "No Tobi."

"Sorry, have I reached the phone of Tobias Schweitzer at the construction
site?"

"No here Pakistan Achmet."

Pakistan, not Turkey. Maybe I should try again tomorrow.

Frozen

Unclear

Disappear

alanya

Night falls, Turkey

Dear Stephen,

Soon you have to leave again to travel around the world from one shoot to the next. I only want to send you a few words to say, "goodbye and enjoy your next three weeks." One point in our lifestyles is similar; we each live much of our time in hotel rooms with a few clothes. Tomorrow is Valentine's Day, and I will open your gift that you sent me a while ago to Berlin. It's funny, my family accepts you more than many other friends of mine. You are the only person who is interested in what I'm doing here in Turkey. Thank you for thinking about me. Thank you for dialing my number.

Today the main contractor threw me out of the garden project. He said it would be a waste of my time, and that I have enough to do with the building site itself. "It would make no sense for you to deal with this garden project any longer." I can't believe that I have to leave it. I had just started with the dry river, "couru derre," and for a few months before that I had been waiting impatiently to begin. They have been blocking me all the time, and now I have to stop this work altogether. My brother, who was on the site when they told me of their decision, took me in a quiet corner and told me to stay calm. But I couldn't.

I was so depressed. I took my Walkman and ran. You know how I do this. My usual reaction to coming up against a wall that I can't find a way over. I ran down the hill, down into the falling evening. Far in the end I could see the snowy heads of the Taurus Mountain. I think about my place here, my purpose. I accepted staying somewhere lonely, in a place I don't like. The project has to be ready on time, and make as much money as possible, and within this simple structure, my hopes of realizing a part of my garden dreams now seems ridiculous. I wasn't expecting to spend money. I only wanted to move a few rocks from one side to the other, make things more beautiful. I feel so sad because I had waited so long for the chance to start, and now I've barely begun and I must stop. Tears come to me.

I run as fast as possible down into this strange landscape. It is a very poor part of Europe. In front of me I can see a few small houses. In Germany cows would live in these structures. They have no heating systems. There is in most cases only a fireplace. Once I went into one of these small houses, the home of an old woman. I asked for directions. Right away their grandson had invit-

ed me for tea. They are a very warm people, here. The house was all contained in one small room. An iron roof without insulation. Through the cracks by the door you could see the sky with its stars. A carpet lay on the floor, where we drank the tea. There was one bed and an electric meter on the bare concrete brick wall. That's it. This is Turkish standard. Visiting this home, I could see why the laborers understood so little of the standards on our German building site.

I continue to run. I pass old people talking together on the street. They're spending their evening having a small chat, sharing each other's company. Their gazes follow me as I run past them. They seem to wonder about this stranger running in the night. In their front garden I saw orange trees, and I remember that there are many warm days here also, although I have not experienced them. By the time the warmth returns, I will have left Turkey already. Where I will be then, I don't know.

A dog starts to run behind me, to follow for a while. He is a companion, and I enjoy his presence. But then he's called back to his owner. I continue on, crossing a small hill into the green valley of the river Dimchai. I can see a few farmhouses. In general, though, it's quite uninhabited, quite empty. Further up in the direction of the mountains, the pine forest remains dark, a shadow in front of the dark blue sky. The air is cold and fresh, like the colors of this night. The evening's usual storm starts to rush down from the mountain. Now the river-valley, too, begin to darken. I see a few lights coming out of these Turkish homes, where I would be only a visitor.

Finally, on top of this hill with the old oak, I have to stop for breath. I need a break. On the other side of the street I climb up a ramp and cross a small field. I take a seat on the ground. It's very damp, because this clay-earth holds water for quite a while. Under these few small trees I feel safe and private; alone and emptied. Now I take this time to look across to this evening's sunset. I breathe, and smell the clear night air, and I forget for a time about the lost project. I calm down again.

I think of how truly fortunate I am. I have so much. I have more freedom and independence in some way that I value, than all these people I've just passed on the street. I have to forget my garden project here. So what? A time will come, and I will know when the place is right.

From where I sit now I can experience in peace the beauty of this strange and wonderful landscape. The scenery built by these cypresses, the smoke of burned wood above the small houses, and its smell... The barking of dogs far away. It is strange how extreme beauty is many times experienced in moments of pain or anger. All of my senses seem newly wakened.

I can see a few people walking down the street. Most people don't own a car here, they walk all the time, up and down the winding dirt roads. Children play games on the street with a ball into the late evening. They own few possessions, they are not spoiled nor bored the way our western children most times seem to be. They use the world around them and each other, for entertainment. For a moment, watching them tonight, I wish I could play with them, as a child. I think of how wonderful it would be to escape from all of my jumbled thoughts, to jump back into the world of a child. No responsibilities, no worries, with someone older and wiser to care for my well-being.

I start walking back to the building site. I think perhaps the others may be worried about me, I've been gone a fairly long time. On the way back, I look over to the path the builders take on their way to their sleeping shelters at night, or in the morning on their way to work. I see the silhouettes of, perhaps,

four people. When they come closer I see that it is Murat and some of the other workers. They are smiling and laughing together. When I see their dirty clothes I am reminded of my own garden-work days, and I feel a little bit jealous. I would prefer to work like them, with them, but as a building-site manager it is unlawful for me to work with my hands on the site. I have to say, though, I've broken this strict law quite often. It's impossible to watch young men, barely more than children, lifting and carrying heavy materials almost as large as themselves, without helping. When the group discovers me standing in the path they come closer. They seem to be happy to see me, and they invite me for a cup of tea. Most of their words I cannot understand. "Tchai" means tea. "Alcardesh" means friend, and these two words explain more, in this lone night, than entire books could. I follow them, thinking, "Let the Germans and their Turkish partner in the hotel on the hill fight amongst themselves." I'm not interested in eating with them tonight. Instead, I am glad to be a part of this friendly banter, happy to have contact with these pleasant people. They place me in the middle, showing respect. I'm a kind of "patron," or boss, to them, but I know they talk amongst themselves often about what a strange sort of boss I am. There exists here a definite hierarchy among the laborers and overseers, that seems in most cases accepted as normal. But, of course I can't imagine speaking down to another man, especially when he's working incredibly hard to get a job done!

When we enter the doorway, everyone takes off their shoes and I do the same. Murat brings me a pair of house-shoes. I follow the others in through the entrance and to a small room containing five beds and a table for eating. Everything is tidy, as much as is possible under these cramped conditions. We all wash our hands, and eat together this common, tasty food of mostly tomatoes and onions. They talk about their home in Kaysere twenty-four hours away in the high-land up in the mountains. Their families are still living there now. They tell me how many brothers and sisters they have. They talk about the beauty of women. Listening to these stories, I think hard about these men, many so young we would consider them children, and their lives. Many of them work harder than most laborers in Germany. In most cases, their entire family lives off of their 150$ monthly salary. Knowing this, sitting here in the presence of these men, I feel guilty and spoiled. I dream my dreams about gardening and they are struggling to survive. And still, though they are homesick and overworked, they are laughing together. In my pocket, I feel my mobile phone which connects me so often with you. I take it out and give it to them, so that they can phone their families.

After we talked a while a young skinny boy with a baseball cap asks me something that at first I don't understand. He makes funny movements. We all laugh. Now they all try to explain to me what he is asking. Finally I understand what they mean. They are talking about a Labour party where all of them had danced. I remember the wild Azerbaidjan pavement builders with their rough Russian-like dance and the Marmor laborers with their dance showing close friendship. At the party, the only thing that I was able to show them (because in Germany nobody dances a dance of their homeland any longer) was my headstand. With the rhythm of their music I had waved my legs in the sky. Now, these men want me to show them how it works. So, while they clap their hands to the sound of their small radio, I start to make my headstand. Later, I teach them how to do it. We have a lot of fun, and I forget what I was sad about. (During the next few days whenever I meet one of them on the building-site they have to show me how far they are with their headstand exercises by attempting one right then and there.)

Quite late I leave their flat. It's cold. I think of you going to your shoot and these Turkish friends going to bed. It's sad that you don't have the chance to meet me here in this world. Take your pillow in your arms, I do the same.

See you soon,
Your Tobi

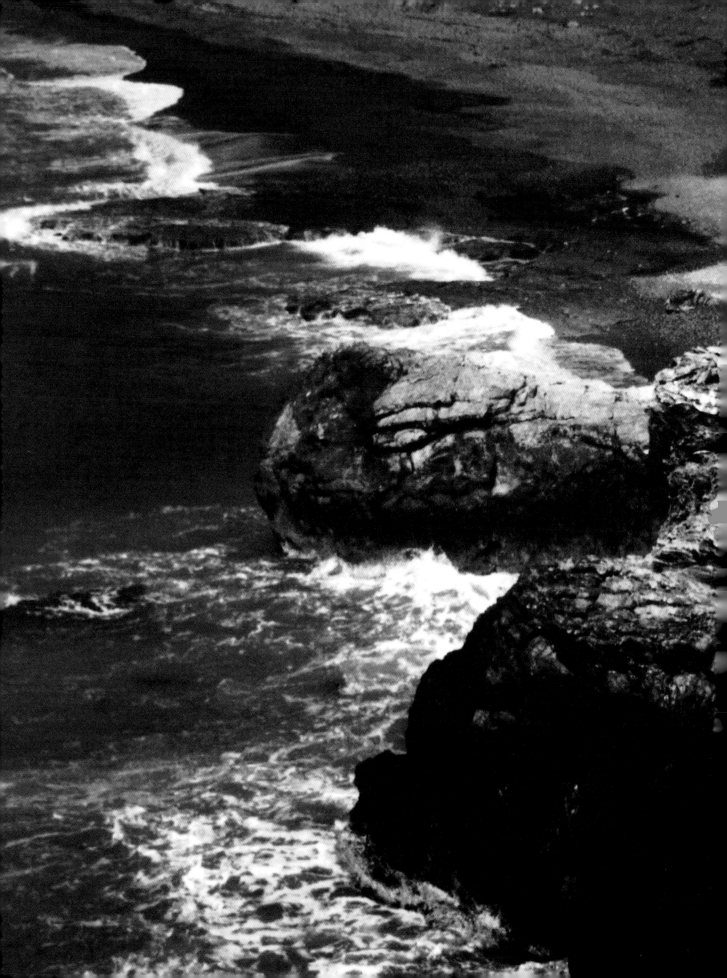

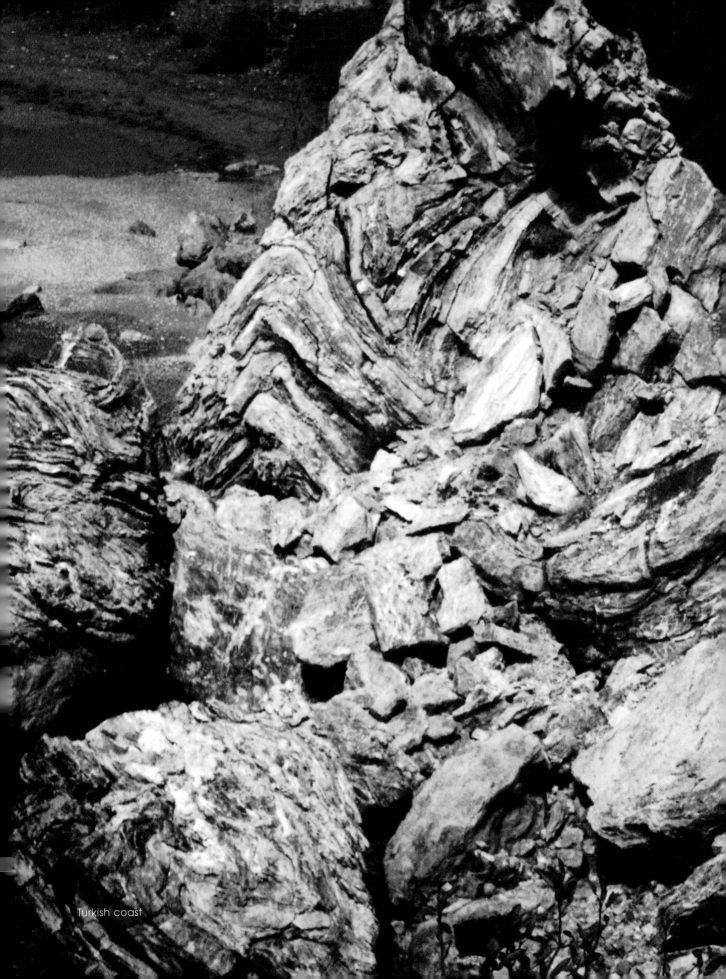

Turkish coast

White tree curtain

White stone, Dimchai River

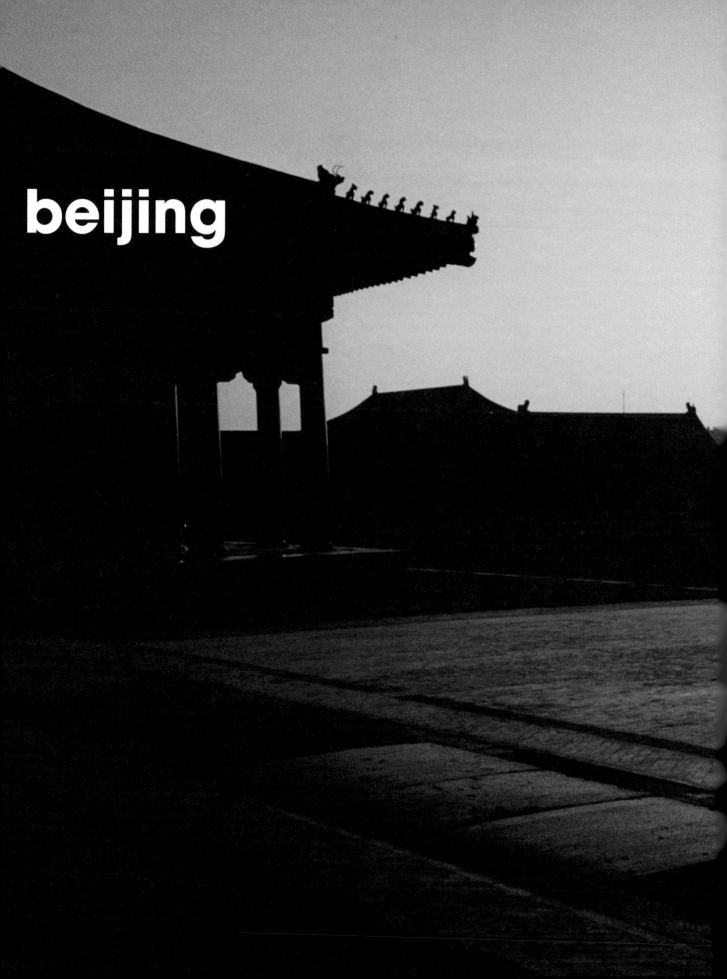

beijing

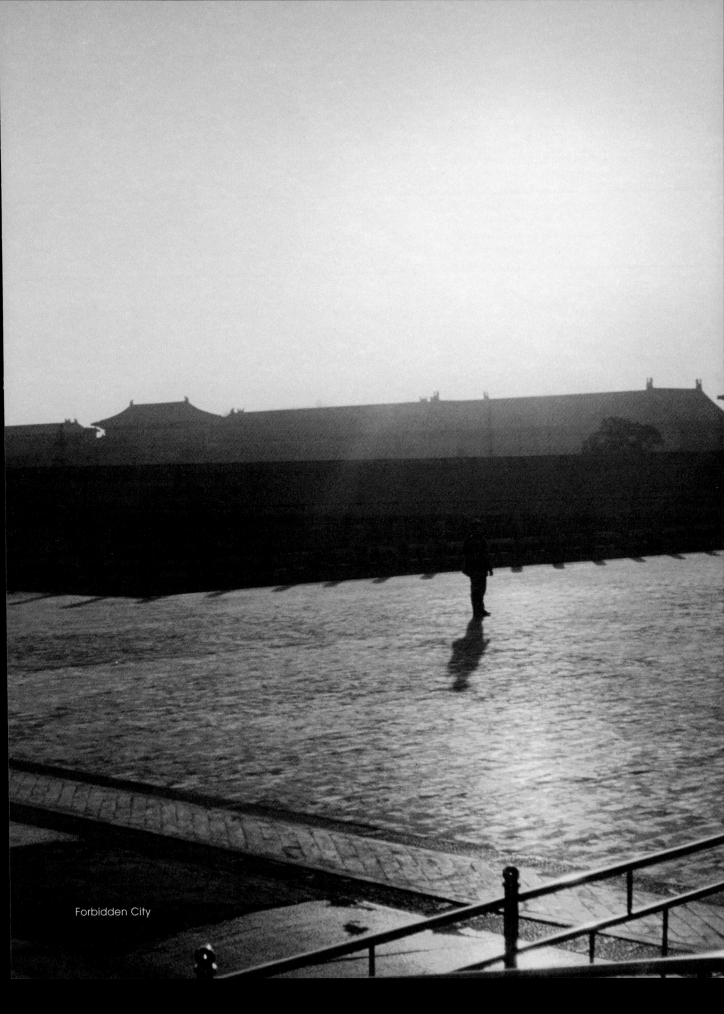

Forbidden City

S The day after Thanksgiving I am waiting for Tobi at Heathrow airport in London, and we have a connection to make to Beijing. I am arriving here from New York and he is coming in from Turkey. Sounds like a bizarre connection? I had asked him, "How do we find each other at the airport?" In typical Tobi manner he says, "We have four hours, don't worry about things like that." So, I'm here, standing at the airport terminal I arrived in, thinking, "What do I do now?" He may have his brother's mobile with him so I decide to try that first. As soon as I start to punch in the number, I hear, "Hello, hello..." behind me. Tobi always uses that "double hello."

Hours later, we are in "my" part of the world. Even if my family hasn't lived here for three generations, coming here is hitting me close to home. From the plane, we see the mountains of Guilin, and I remember the photo I have of them on the wall of my bedroom. I'm excited to be here.

Now Tobi is taller and blonder than ever before, and I can spot him a mile away. If I momentarily lose him in a crowd of people, I can find him instantly.

The pictures of the Forbidden City were taken about an hour after we landed. I didn't want to ease into it. I was going for major culture shock: the full effect. Here it is, China! Like stepping off the plane in Egypt and seeing the pyramids. The Forbidden City at sunset. Five hundred years of history. Right before it closes. Tobi is lit from behind by the setting sun, talking with our guide. Everything is golden. And the crowds of people have gone. It's magic.

Being in China makes me think about my roots. Although Tobi keeps asking me, I don't know so much about them. All of my life, my family was more western in the way they lived, and I had a wish since I was young to travel to the United States to live. I do remember though, my grandparents always spoke to my parents in Chinese, and I learned a bit when I was young.

At the beginning of this century, my grandparents escaped from China by a boat, apparently to escape communism. When I think about my grandparents, while here in Beijing, I wonder what they thought then regarding their future, starting a new life in the Philippines with nothing. I feel thankful to be here, partly because the knowledge of their past had never affected me so intensely before.

A couple days later, we visit the Great Wall. My camera conks out, so we return with only a couple of shots. The walls are endless climbing up and down the mountains. Some of the path on top of the wall parts are completely vertical. It's great to see how much Tobi enjoys being here, running up and down the pathways.

Red staircase, Summer Palace

Red gate, winter branches

T It's winter in Beijing, or what was previously Peking. I'm surprised at how modern the city is. There is not a big difference between western high industrial cities and this place, at least not at first glance. I prefer to see more of the old China. I ask Stephen if we can visit the old Summer Palace. I had heard about the gardens. The palace was built for the royal family so that they could escape the heat of the city during the summer. Built at Kunming lake in 1709 it consisted of 140 Buildings, and some hundred different landscape pictures created here still remain. It was once one of the best gardens in China. After the destruction during the French and British Invasion it was rebuilt. In 1900 at the next big rebellion most of the park was destroyed again by the Europeans. In 1983 the government started to reconstruct as much as they could. In 1986 it was opened again to the public.

After a one hour drive we arrive at the Summer Palace north-west of the city. It's quite cold and the sky is grey. I give Stephen my jacket, because he looks colder than I. Maybe he forgot how far north Beijing is. When I see him in his thin jacket I think, "This is Beijing darling, not Manila."

We arrive at the palace late in the afternoon, and we know that we can stay only for a few hours. At the gate, we pay the entrance, and then enter. The overwhelming majesty of this place quiets us. We walk without speaking, unwilling to break this full silence with today's voices. We travel into another time, the age of the last emperor who lost his power and his country while he was still only a child. This Summer Palace was only used during the hot, dry summers of Peking. Now, it's winter, and somehow the empty cold is fitting for this beautiful, quiet place, which today is only visited and no longer lived in. We walk further into the grounds. All around us fog is held in suspension, and turns soon to a very fine snowfall. The flakes remain tiny and sparse; it seems they don't want to disturb the atmosphere of this sleeping wintry palace. The autumn is past. Only a few leaves are waiting for a quick gust of wind in order to drop back easily to the cold, waiting ground.

These bridges, paths, streets, and squares stand in a wonderful, powerful harmony. This place was created with a strong respect for the spiritual. I had known this, of course, before. In theory. Today I am allowed to experience it with my own senses, and I feel blessed. Its beauty is timeless and somehow very sad, and expressive of a finished time. Walking, pausing now and then, the compositions are pure, aged, and perfect. I am in disbelief, in a state of complete wonder at meeting this world. This place is something entirely ancient, and I remind myself that the China of today is still infused and inspired by this left-behind time.

We visit most of the buildings on our own. On this chilly day there are very few visitors here. We arrive at the main lake spreading out before us enormous and almost-frozen. I rest, standing here, astonished and fascinated by this amazing landscape. Stephen and I walk together, silent, toward the water. Looking down the length of the lake I can see in the dusk the long Seventeenth-arch bridge leading to the island where The Dragon-King Temple stands. The sky and the lake meet with the same pale grey of the horizon. There are no colors in this fog, only the slightly darker grey of the bridge and the island with its smudged trees and palaces.

We continue walking. We discover a waterfall of stairs, not sure whether it is only a staircase or if water runs here in the spring. There are thin streams running under curving bridges. Mystical dark gathered trees hold conversations with still, arrogant rocks. We note the "holy rocks," brought here from all over China to the people's god, the emperor. Pieces of the country far from this place, symbolising the spirit of other regions.

Everything in front of my eyes lives inside a dream of something past. The reality of three dimensions expands to include a fourth dimension of dream and belief. It is beneath or within our real world, the one which we can see. I feel like a child infinitely small, and touched by the grace of this beautiful, ancient fairy-tale world. The last emperor of China was born as god; when his rule ended he became a gardener, somewhere in Beijing. The story of this child is a strong, sad story, which no one could write better than life itself has.

Today, I close this ancient chapter. It lies in the past. Like a heavy door it shuts behind me. When we leave the Summer Palace, I feel strangely that all of me does not follow the path of my body. Not yet. The parking lot seems unreal, so far away from the world just beyond the gates and wall beside us.

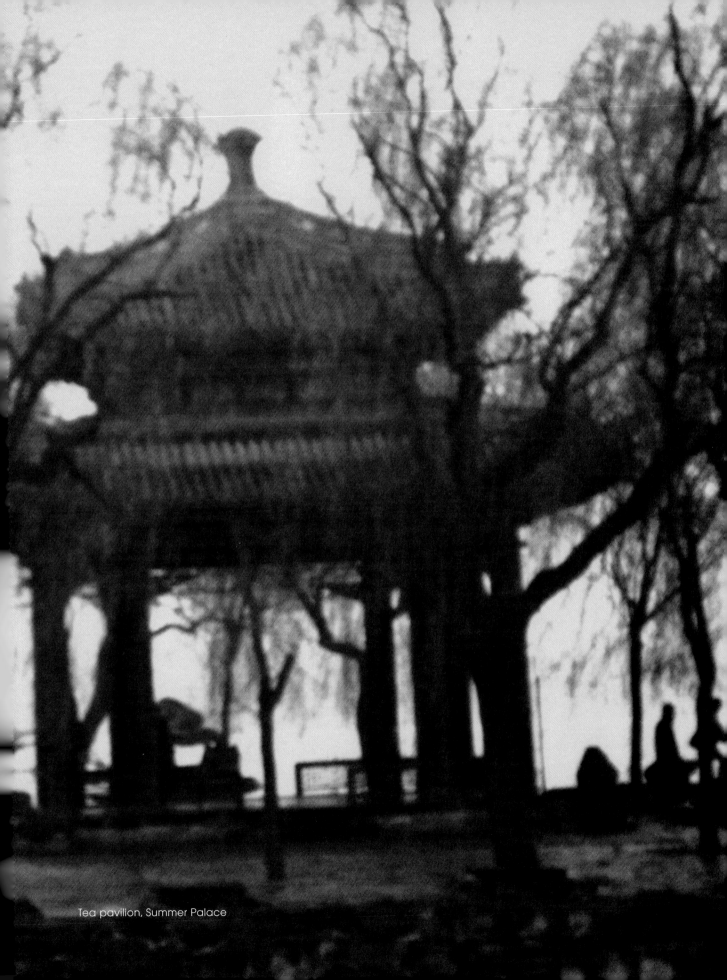

Tea pavilion, Summer Palace

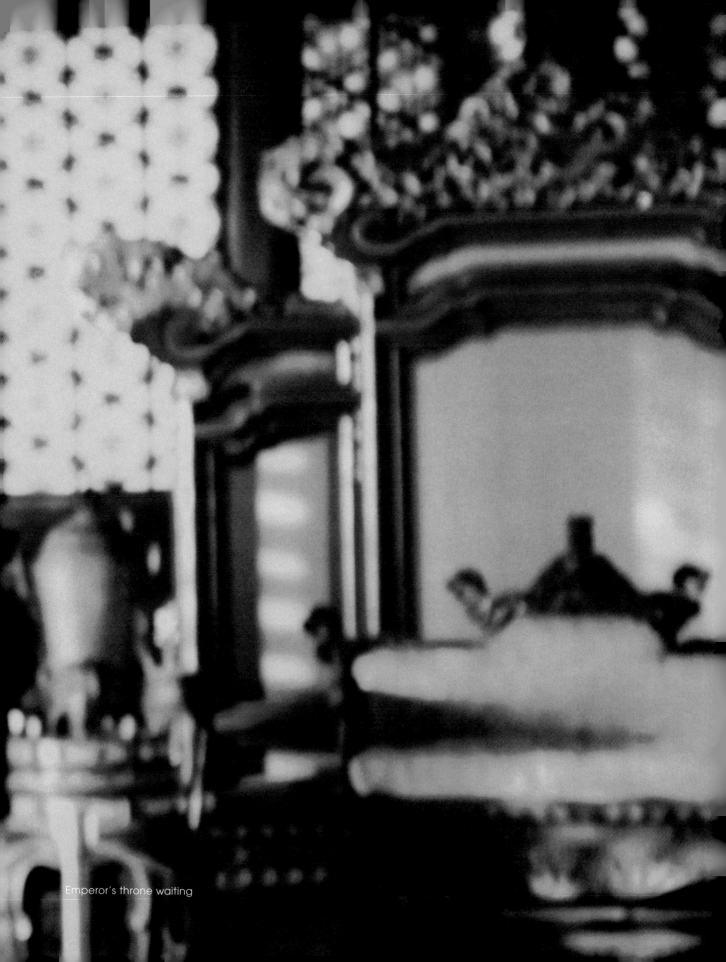
Emperor's throne waiting

View from the peak of the Summer Palace

The scenery's many levels as viewed from the peak of the Summer Palace

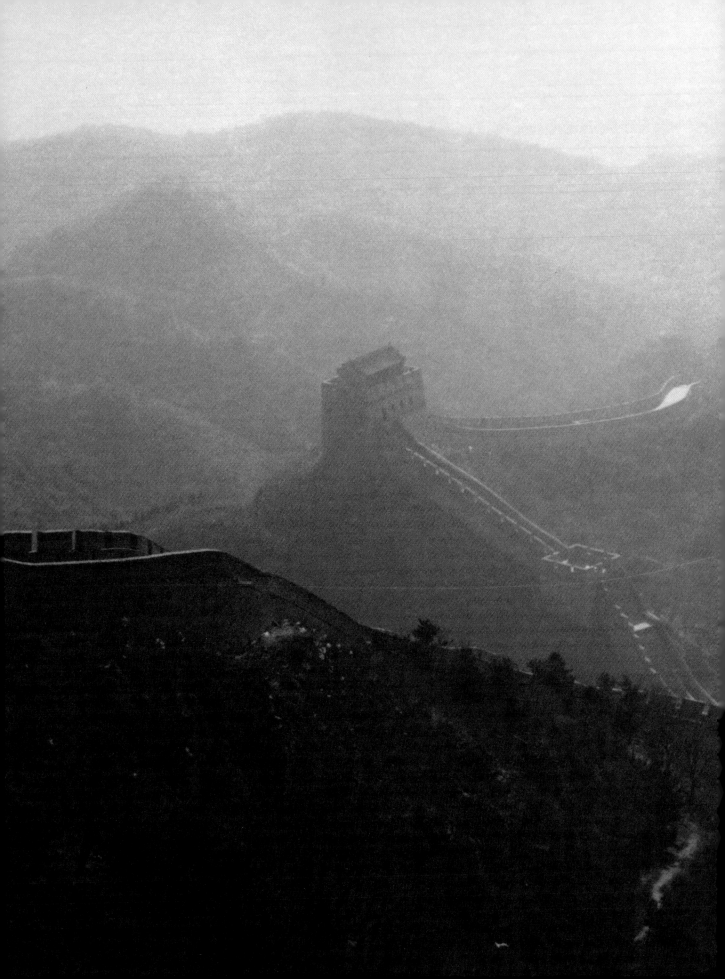

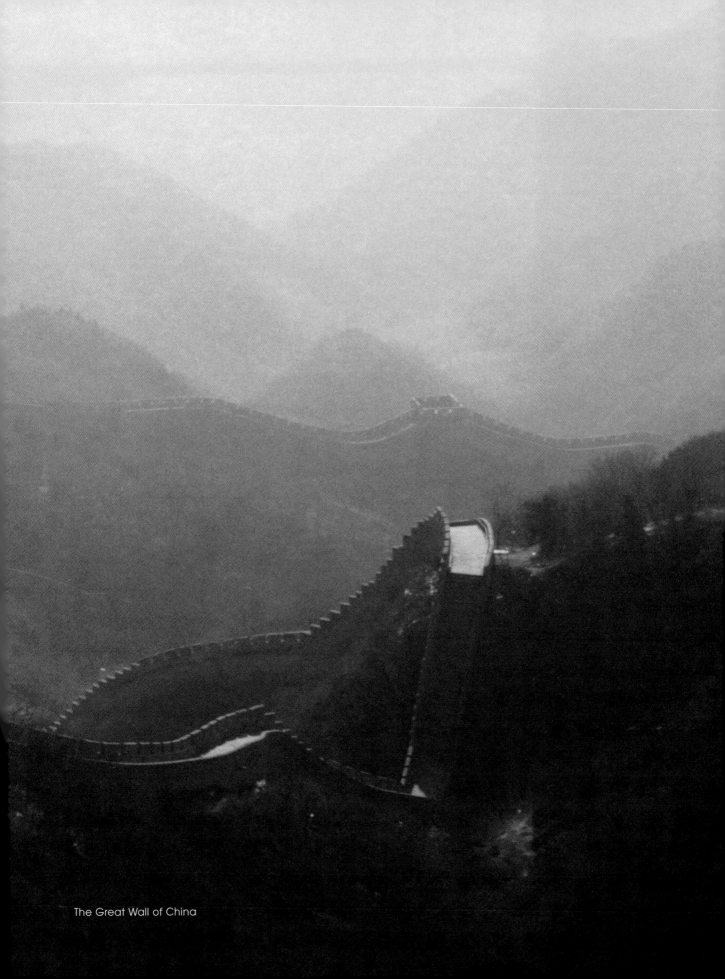

The Great Wall of China

Passing from room to room, from space to space

kyoto

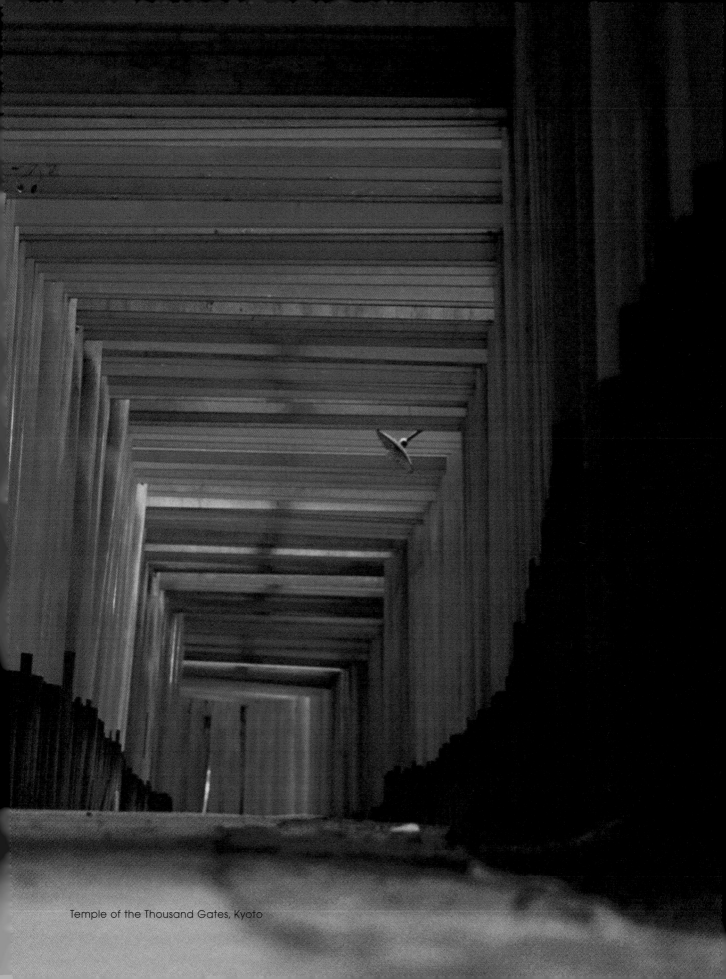

Temple of the Thousand Gates, Kyoto

T When Stephen tells me that we are on our way to Japan I'm completely surprised. I hadn't thought you could do so much in such a short time. Without asking, I hope that we will have the chance to visit a few gardens during our visit.

S In Tokyo I work with my colleagues almost nonstop on a shoot for a new cosmetic line, in a hurry to board later on the same day the bullet-train for Kyoto. When they say bullet-train they really mean it, as we quickly hit 300 kilometers per hour just after leaving the station. We pass through most of Japan in just two and a-half hours.

On the first evening we relax on our room's tatami mat floor. Our dinners arrive in traditional o-bentô boxes, and soon after we finish dinner Tobi excuses himself to the bath. A few moments later I follow. The room is bare except for an odd, square wooden bathtub. In fact, it looks to me more like a crate for apples or potatoes than a place to wash yourself. The rice-paper screen next to the tub is partly open to the outdoors, and the mixture of hot steam from the water and the cold autumn air create a foggy mist in this small, damp room. It's as if a strange Japanese soup is being made. Tobi motions for me to come in with him and shows me there is room in the square box. "No, Tobi," I say. "Too much sake and too much jetlag. I'm going straight to bed."

"Could you pass me the shampoo?" he says. I reach over to the sink for the small tube. As I stand in front of the wooden tub to hand him the shampoo, he looks up at me.

"Are those the only clothes you packed for this trip?"

"Tobi, I'm really tired," I say, growing annoyed. "Of course not!"

Before I can even make it to the next thought, Tobi jumps up, grabs me and pulls me down into the wooden box. Suddenly I'm sitting in the tub. My head is bobbing next to his just above the water, and my shirt, pants, belt, socks, everything, feel indescribably soaked and clingy next to my skin. Laughing, we strip off every wet piece of clothing and toss them from the bath. We slide the rice-paper screen further open and look through to the tiny Japanese garden outside. Like a cut paper silhouette at night, we see a temple with a moon in the background. "That's Kyoto. The real Kyoto." We laugh.

Later that night we fall asleep on the tatami mats on the floor. I feel like a child camping, laying on the ground in a Japanese sleeping bag. Tobi has pushed back all the paper screens along one wall, and I can look out into the night. The next thing I recall is a low noise waking us. Tobi jumps out from

Tobi in Ryoanji Temple garden

under the covers and is standing in the garden in his underwear.

"It's an earthquake! Wake up, wake up!" he calls.

"Yeah right, Tobi."

I think he's up to another of his jokes. It would be the second this evening, a bit much for me, so I roll back over and fall back to sleep thinking "you just stay out there all night in your underwear, Tobi, feeling close to the plants and communing with your garden dreams. Just leave me out of it."

The next morning we learn it really was an earthquake.

T Today we are starting with our "garden trips." Stephen organizes a car to drive us around. We are lucky to have a guide, who, although he speaks almost no English, can understand that we want to be taken to see gardens. And, like two blind visitors, we are driven from one garden to the next, with no stops in-between. In total, there are about 1800 gardens and temples in Kyoto alone! Of course, we don't have time to visit them all, but we make a fairly honorable attempt.

I discover a world of continuity in these Japanese gardens as I have never before experienced. A certain peace, a quiet, clear abstraction. The gardening theories and practices of the West seem so overdone in comparison. The Zen gardens, especially, contain a very personal spirit. Most of them are a couple of hundred years old. Gardens were used in Japan as a practical artistic element for the transformation of common issues into religious practice. Famous gardens like "Ryoan-ji," with its fifteen rocks, or the silver pavillion "Ginkaku-ji" are only two examples which hold even today cultural and artistic importance, in Japan and all over the world. I have read about these people and their beliefs, their reasons for creating clean, mindful spaces within their everyday world. After each visit to one of the temples here, I wish I could prolong my stay. In many of the gardens here, I see elements of what I myself idealize and respect in creatively using elements of the Earth. Many of these gardens show me the essence of different landscapes I have seen throughout my life: Abstractions of forest-covered islands, shown by a small rock overgrown with moss or the spirit of an ocean, heavy with waves, in the lines drawn between white pebbles.

Our last day here, we visit "The Temple of the Thousand Gates." One orange gate after another stretches unbelievable miles into the mountains surrounding Kyoto. This is for me a world wonder more than anything else.

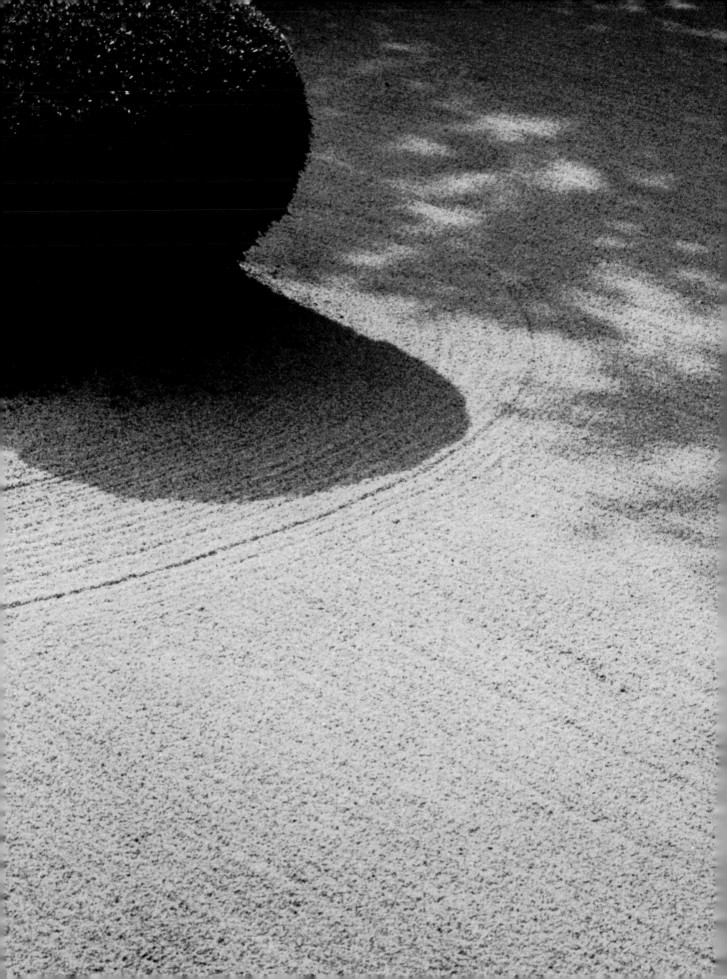

Circle and line

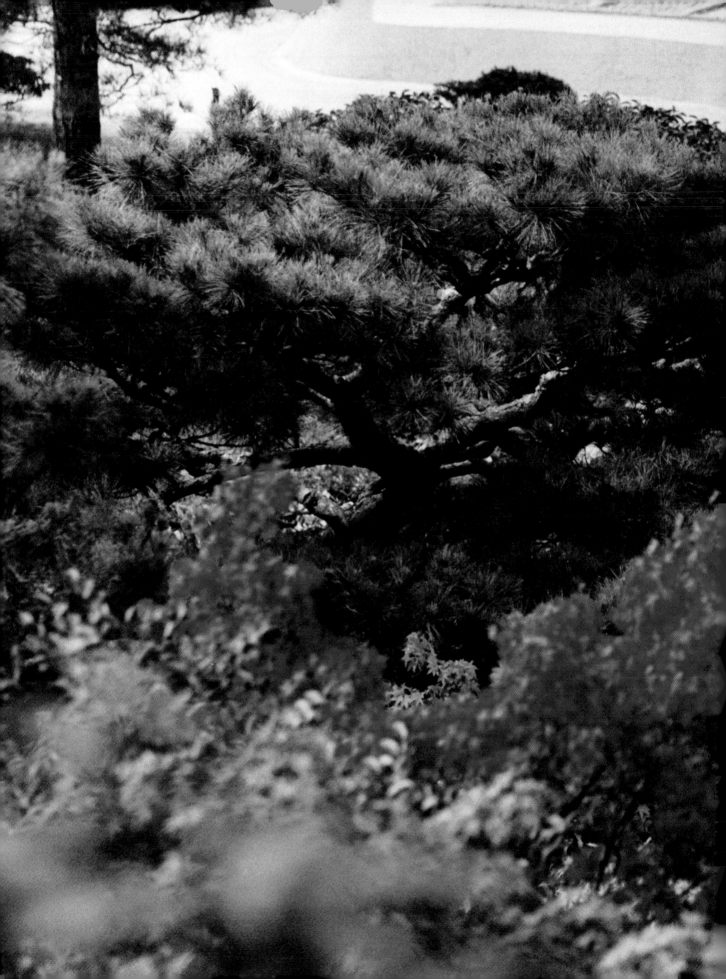

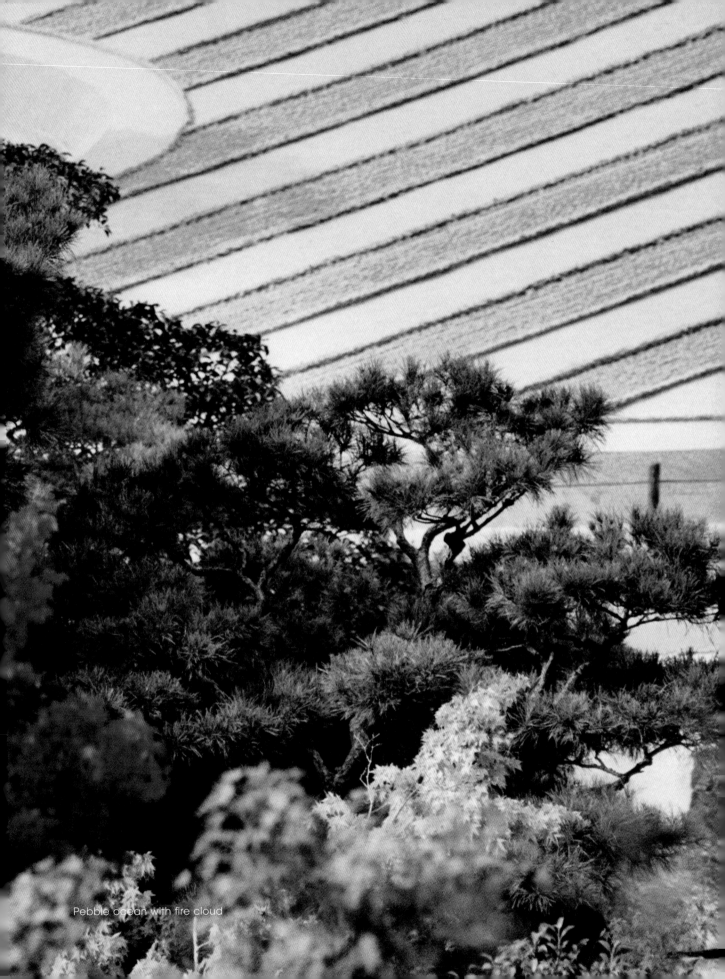

Pebble ocean with fire cloud

Shadow cut-outs

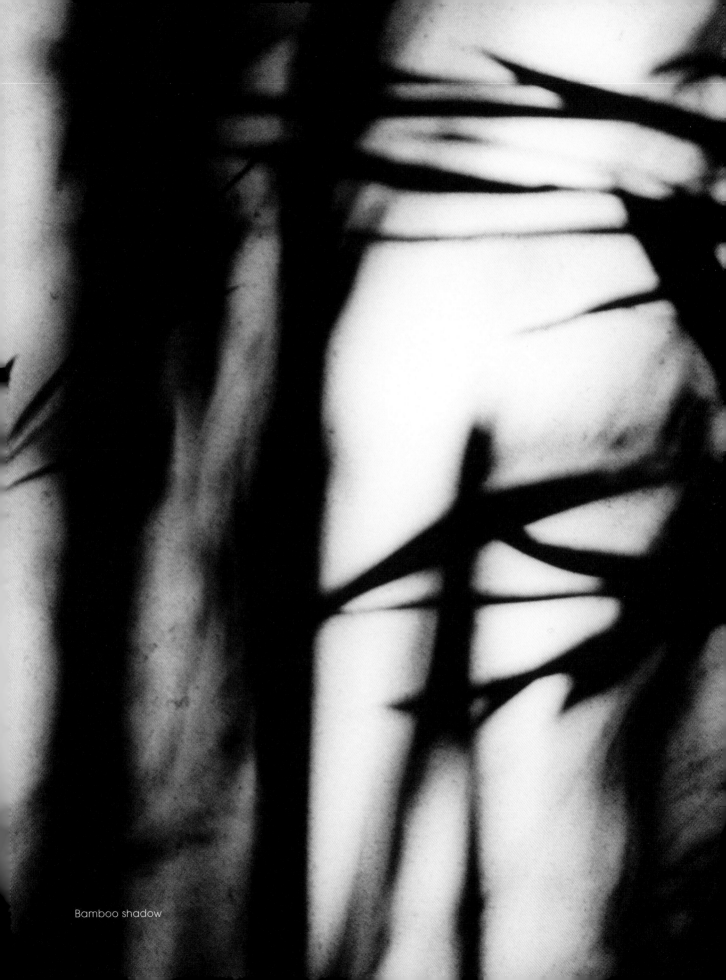

Bamboo shadow

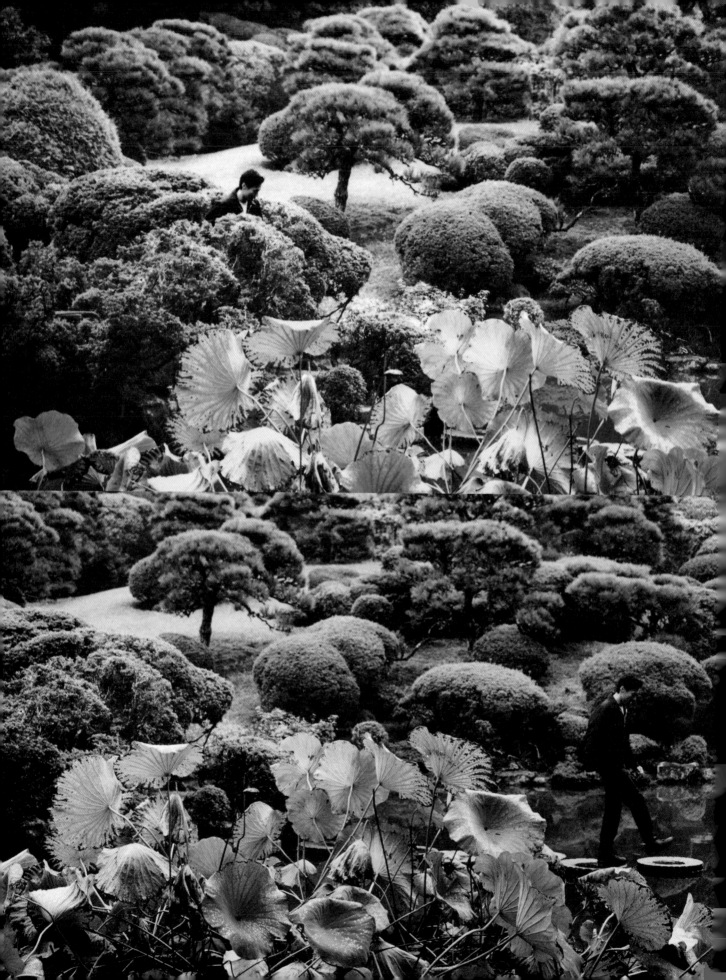

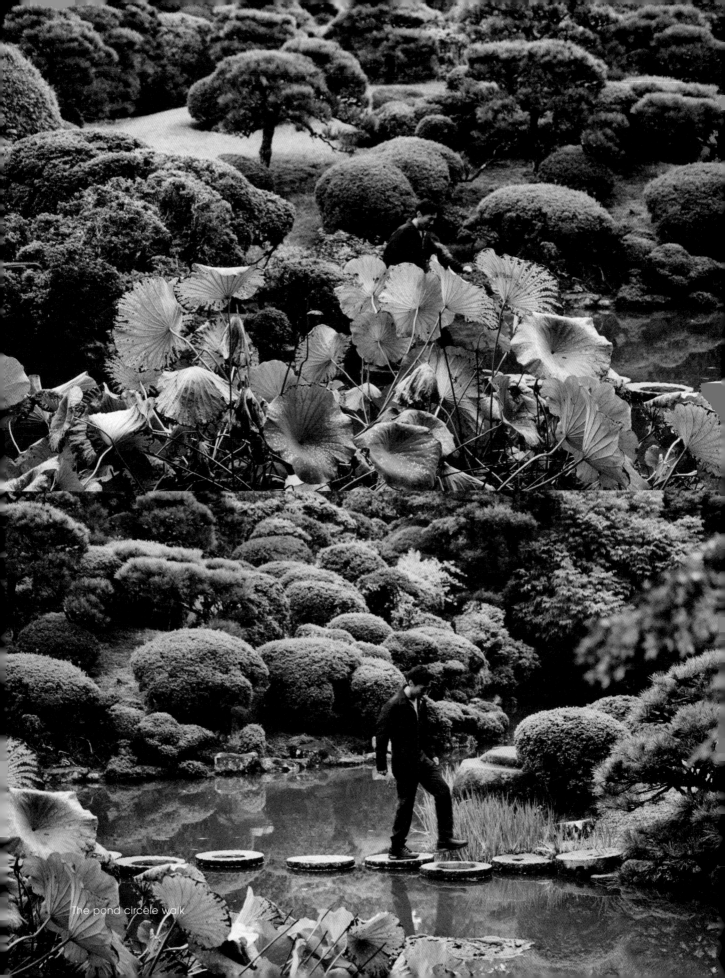

The pond circele walk

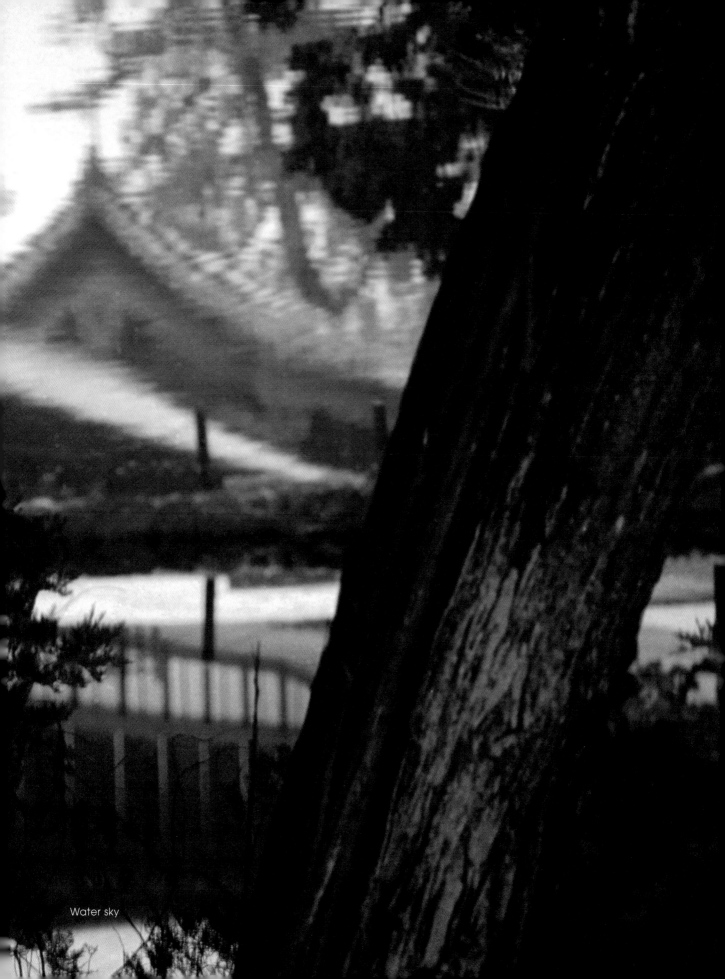

Water sky

Bamboo sky

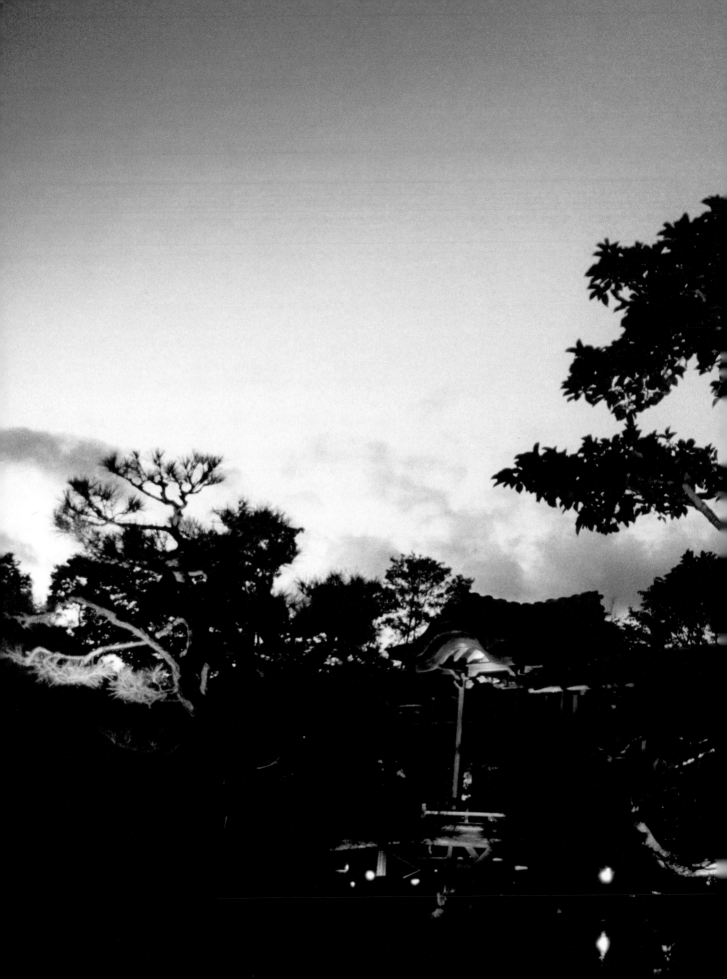

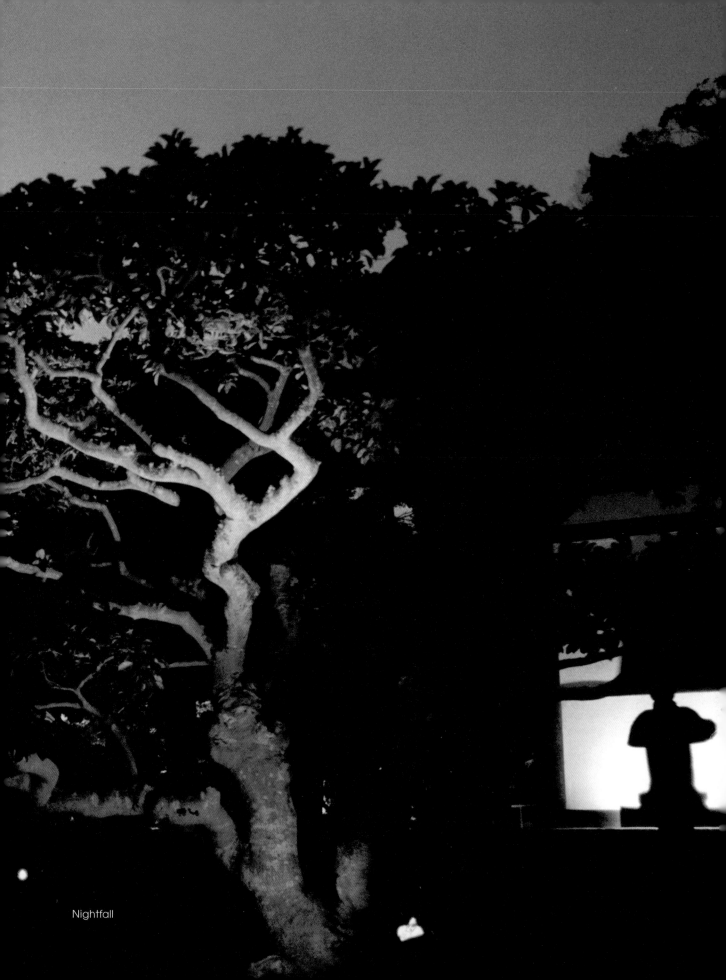

Nightfall

bangkok

Monks' robes

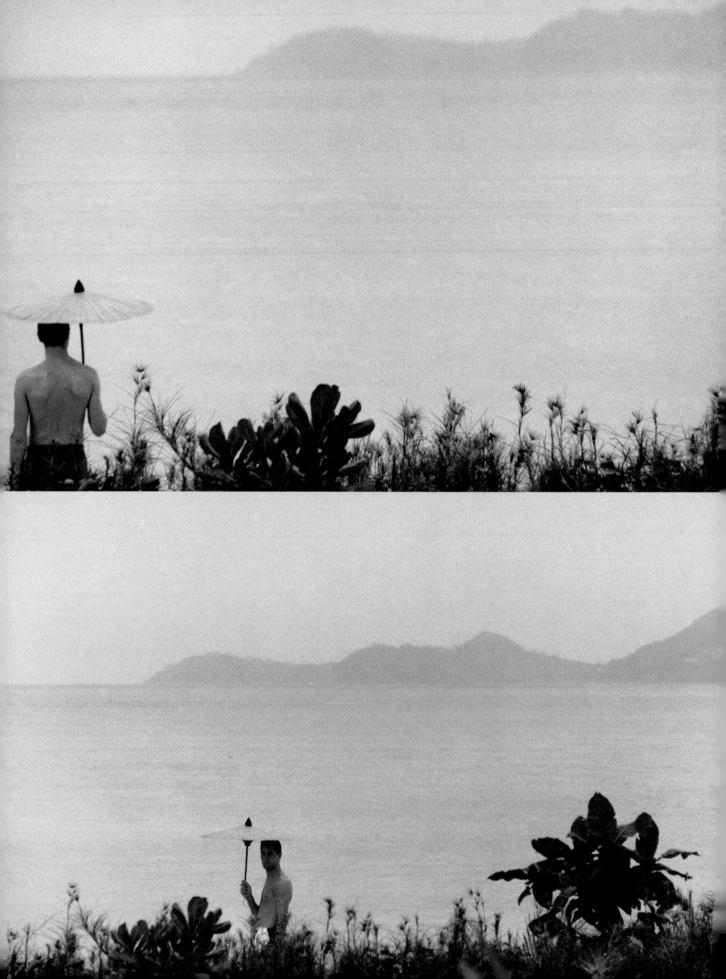

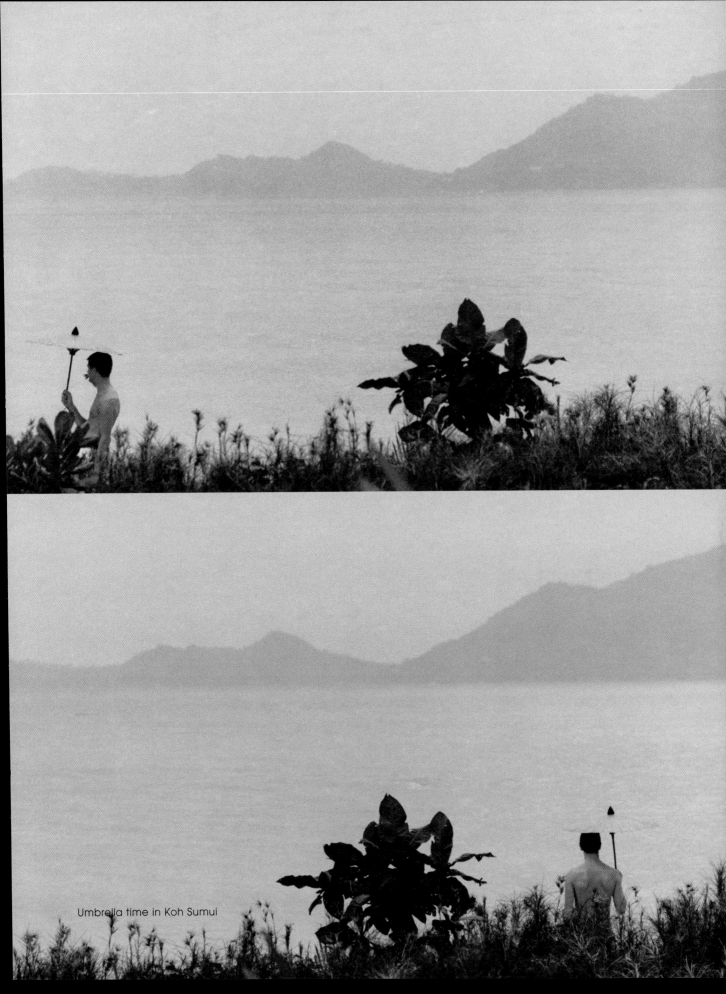

Umbrella time in Koh Sumui

S Watch closely, I feel like telling Tobi. This is as close as you'll get to the earliest "me." The me of the past, my childhood world.

I now feel detached from this Southeast Asian world, but it is still a part of me, as much if not more than my Chinese heritage. Tobi has shown me his Alps; now here are the temples. I've seen his clean German highways and the Autobahn; here are the crowded, noisy, smelly roads of a vast third world city seen from the back of a "tuk-tuk." I know he loves to walk in the Hergenrath forests; here is a walk through banana and coconut jungles. A jump in the lake? Here we have only the warm island water of Koh Sumui, one of the Thai islands. Growing up in a big city like Manila, I used to dream of living on a paradise island like this. As children we travelled very often, and at one point I wanted to be a tourguide when I grew up. I loved to travel then, I love it even more now.

When I was growing up in Manila, my brother, my two sisters and I played together, riding on our bicycles out in the garden and around the house. Our garden looked nothing like Tobi's farmhouse garden in Belgium. It was more a cross between a suburban backyard and a tropical paradise, complete with one mango tree and three coconut trees. I was especially fond of the mango tree. It was there, in our garden, that I found most of the insects I would collect in boxes. I remember one thing I found particularly entertaining was tying strings to beetles, and swinging them around and above my head in a wide circle, watching their iridescence flying through the air. I stopped when I realized that it was quite cruel.

When I was seven, my father, who had worked also in publishing, passed away. This was really difficult for my mother, especially since we still lived in the home of my father's father. My mother was a very strict Catholic and we went to church every Sunday. I remember how much patience it took for me to sit in this big space, being proper and well behaved. I was happy when I finally got home to my garden and my pets. We spoke English at home, and we were all sent to an English speaking school. It was natural for me, then, to think of studying in America. I had always loved to draw and paint the world around me, more than anything else. At a very young age, I'd begun painting pictures of all my favorite fairytales. At school, I made picture books and pop-up's. As I grew older, my wish was to become a photographer and I started to dream about going to America to study art. When I was eighteen, I did just that.

Today, in Bangkok, which is quite similar to Manila, the too-busy streets are a little overwhelming. Even for me. In Europe there seems to be a balanced ebb and flow in the workings of everything. In Tobi's case, it begins with his mother's house. Her flowering gardens merge into green hills and cow pastures that dip into valleys, that then lie next to lakes, that then flow into rivers, and so on and so on. A divine order bestowed upon the earth. That's Germany or Switzerland for you.

Then there are lands like Thailand and the Philippines. The chaos on the streets

clashes with the proud glimmer of the temples, which stands in contrast with the tranquility of the monks made to jump on and off the boats on the Chao Phraya river. How does Tobi, of the calm, orderly North, fit in here?

How different he and I are. We are both strange mixtures of calmness and turmoil. How often I hope that our differences will balance out in our favor.

T After breakfast we walk around, first to see a few "important" buildings, finding them easily. Playing the part of the tourists. Masses of gold are set within these old temples like Wat Phra Kaeo. They are grand and gaudy. Quite soon, though, we grow bored of this and go to find the calmer parts of the city of Bangkok. As we walk further and further from the center of the city we begin to leave the hectic crowds behind.

The atmosphere of this tropical afternoon reminds Stephen a lot of his childhood in the Philippines; it is nice to see him reflecting. It is fun to hear stories from when he was a kid. I don't hear them that often.

On a small side-street we discover a tiny white temple, very old. We want to stop somewhere, so we enter into this temple in front of us. Behind the white walls that surround this holy space the busy sounds of the streets seem to be far away. Voiceless, we take a seat at the staircase. Nobody seems to be here. Stephen enjoys the sun on his skin, and relaxes here for a time. I decide to explore a little on my own. After a few steps I discover a boy, about seven years old, reading a religious book. The boy doesn't pay any attention to me, he is so deeply absorbed in what he is thinking and reading. Carefully I sit down in a corner and watch him. There is a true and spiritual sense to his being that most of we western people have never found in our everyday lives. A young boy, a temple of his culture, and a book of deep and lasting importance. There is a peace and satisfaction here in this child, that we westerners fight to reach and seldom seem to find, and he just seems to live it in a simple, peaceful way.

Soon Stephen finds me, and we have to get ready to leave. We must both return, he to New York, I to Turkey.

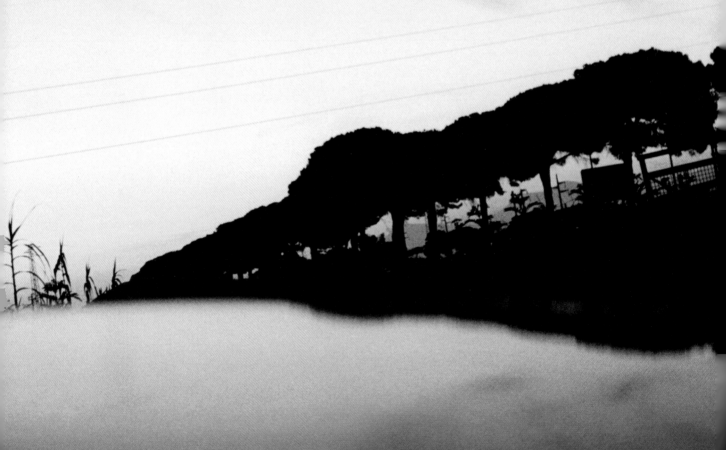

terracina

"Drive your Dream" on the Via Appia to Rome

S It is strange to be shooting with Mario in Naples and Capri, knowing Tobi is only an hour and a half away in Terracina. It's been almost four months since I've seen Tobi. I wish he could have seen those small islets of Capri. They reminded me so much of the vertical mountains of Guilin in China. An Italian version.

After my work is finished, I take the train to Terracina and Tobi picks me up at the station. He looks healthy and a bit sunburnt. After Tobi finishes his work for the day, we take a walk by the beach. The sun is setting and we decide to do pictures of us against the sunset, with the self timer.

T Stephen turns around and looks at me. The sea at Terracina stands behind him. "I can't come to New York." This last sentence of mine has set him deep into thought.

I want to try to explain why I've stayed apart from you all this time. All this time we've known each other, you have a difficult time understanding why I work at these odd jobs here in Europe. Like now, taking care of this older woman, a family friend who wanted to travel to Terracina from Belgium. For a few weeks, again, it has only been possible for us to talk by phone. Now that we have these three days together, I really want to help you understand why I need my space. All my life I have been independent. Yes, there are many people who have helped me. But always there has existed a kind of balance between me and those people. I gave something and I received something. This I can't feel with you. At the moment, with my situation, I'm not able to give in return what you can give me. You are kind and helpful to me in the attention and experiences you give. I would love to be closer in some ways, but you know how difficult it is for me to juggle all my worries. It is just that I have this wish to sort it out on my own, and not let my own troubles carry over into time I spend with you. I feel that I can't give you the attention you deserve from me, because I am constantly moving and working with things that absorb my time and energy. The people who have helped me the most are my family. Like when my brother offered me a job on this Turkey project. Like right now, Mrs. Voss, who didn't have anyone else to travel with her on perhaps her last trip before she goes completely blind. And definitely my mom, sorry, nearly our mom, with her jobs all the time offered in my direction. But I have always worked hard and helped those who have helped me in return.

But I do enjoy being close to you. I'm so happy to have the chance to walk with you here today. It's a strange relationship, but it's ours. I see us both as kinds of dreamers who love to discover and explore new ideas, new places, and we have shared this since we first met. Our lives, lived most of the time separately, create a story of togetherness when we are able to meet in this momentary, circumstantial way.

Here is a vision of mine. There are two rooms, both without light. The first room is owned by Stephen and the other one is owned by Tobi. I opened your door and you opened my door. The light from outside began to flow into the darkness of the rooms. It is simple. At first you heard my name; I heard your name. At first, we were just two people standing in front of each other once in Berlin. Then, you told me about you and your life and I told you about me. You remember me from that time as a party boy, I remember you as a strange, kind person. Little by little we learned about each other, from each other. There would be no reason to dream or exist for myself alone. Enjoying means sharing and that we do in our special relationship.

Tomorrow, I want to drive with you. It'll be great. There is something wonderful about rushing past the landscape, rushing forward, leaving the rest behind you. It's something that means a lot to me.

S After three days in Terracina, I have to return to Rome to catch my flight back to New York. Tobi tells me to put my bags in the car right after dinner so we can take me to the train station. Sitting with the old lady, he says aloud that we are going for tea in Sperlonga, the next town over. Yes, tea in Sperlonga is the key to my freedom.

We drive and drive, and then I suddenly realize we are not stopping at the train station. Nor are we stopping for tea at Sperlonga. I look at Tobi. He looks at me and smiles. I nod in agreement, and think to myself, as the saying goes, all roads lead to Rome. We drive fast with the hood down, and the summer air feels incredibly good. We are heading straight toward an unbelievable sunset. We are also out of film. "The best moments you cannot capture," Tobi says smug.

The Via Appia has the strangest lineup of trees I have ever seen. And they are all silhouetted against the glowing sky like black parasols. We go faster. Tobi says, "Look up, don't they go by like clouds." It's true, the trees are like strange, lacy black clouds that are zooming past us. It is like a hallucination,

On the beach in Terracina

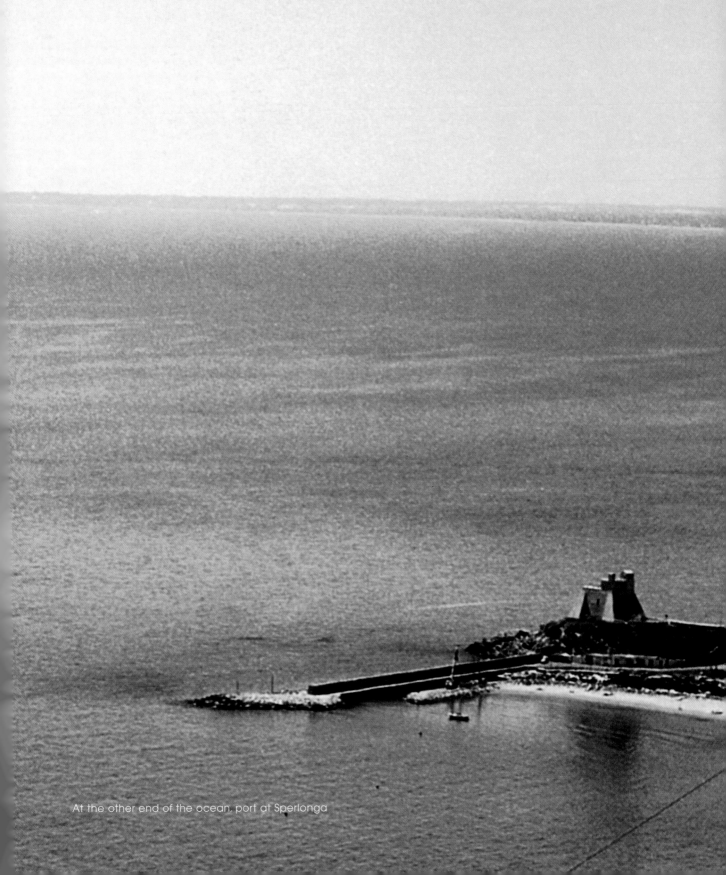

At the other end of the ocean, port at Sperlonga

and we both remark that nature is the best drug. The music's blaring. The sun is a sliver in front of us. Tobi tells me to stand up and though I question his sanity, I do it, and the wind is deafening. This moment is really too amazing, like living in a quick and colorful dream. Being with someone wonderful. Driving fast. Looking up at the sky. This is sheer bliss. I think to myself, "If I die tomorrow, I would be happy, having experienced this." It makes every minute with the unbearable old lady worth it. I know why I'm here. I sit back down and joke that this feels too much like a cheesy movie. But one that you are surprised you enjoy. A "Titanic" moment. But ours, tonight, is of course is better because we are not acting. We're real. We're driving into the sunset. We've escaped. We're going to Rome.

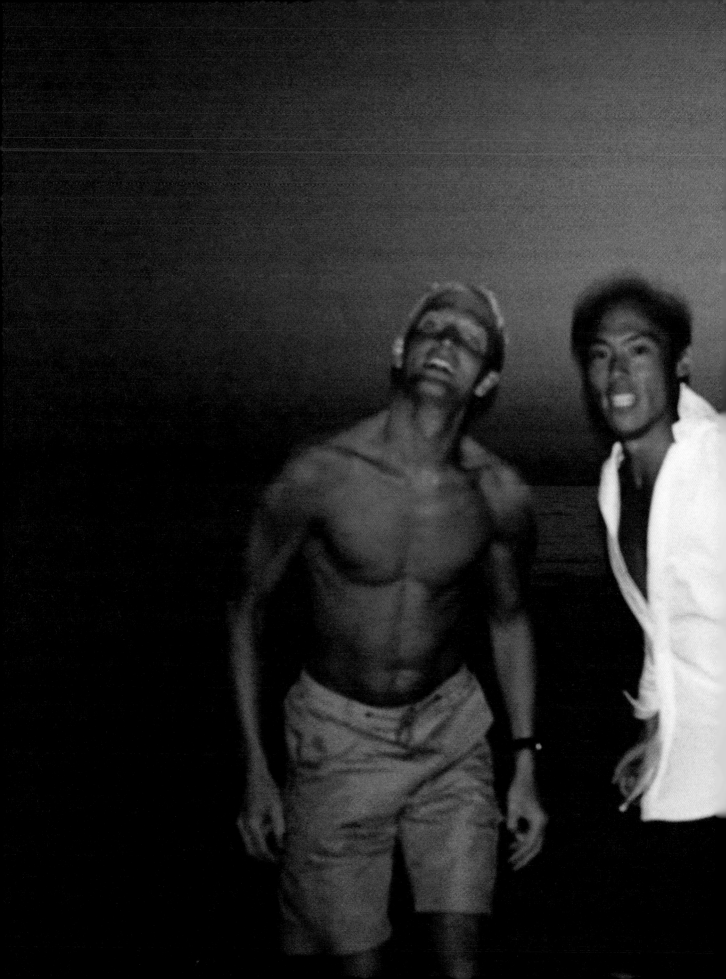

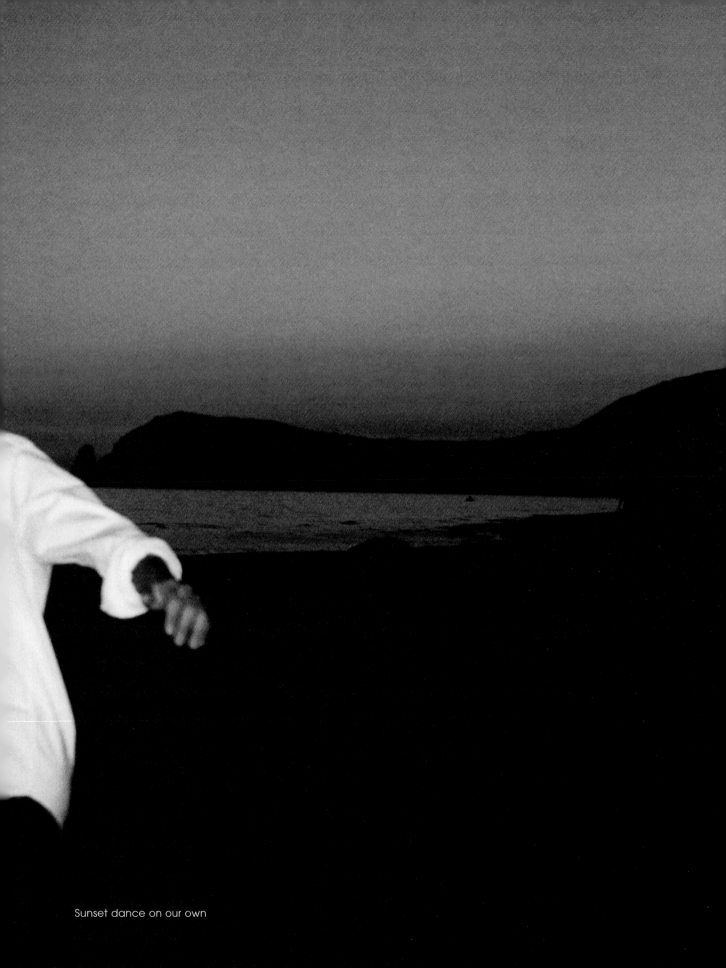

Sunset dance on our own

Tree mountain walk

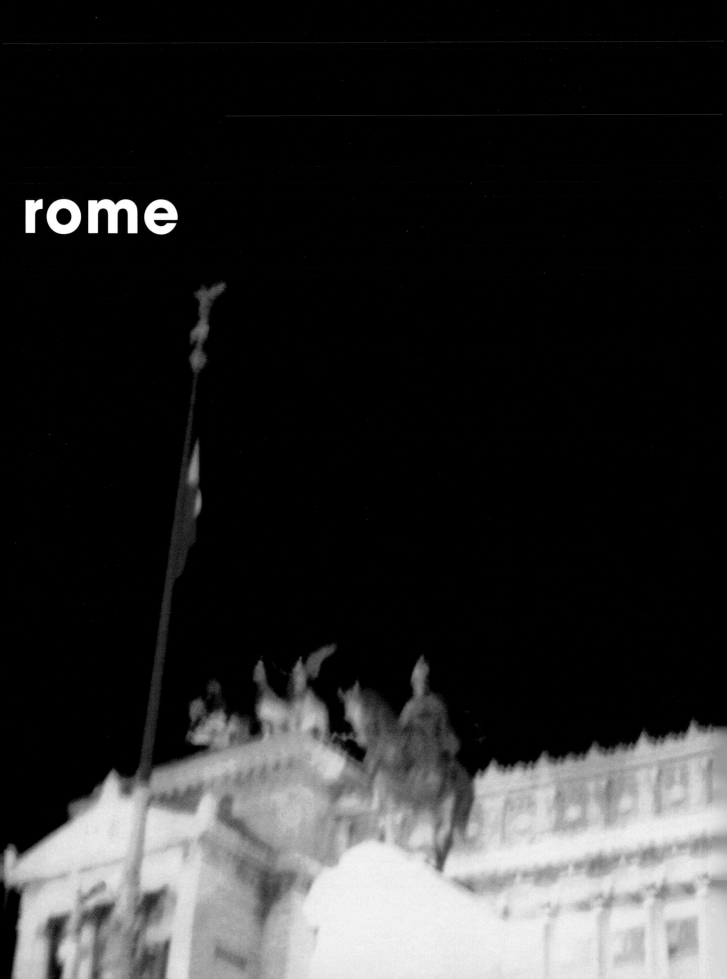

rome

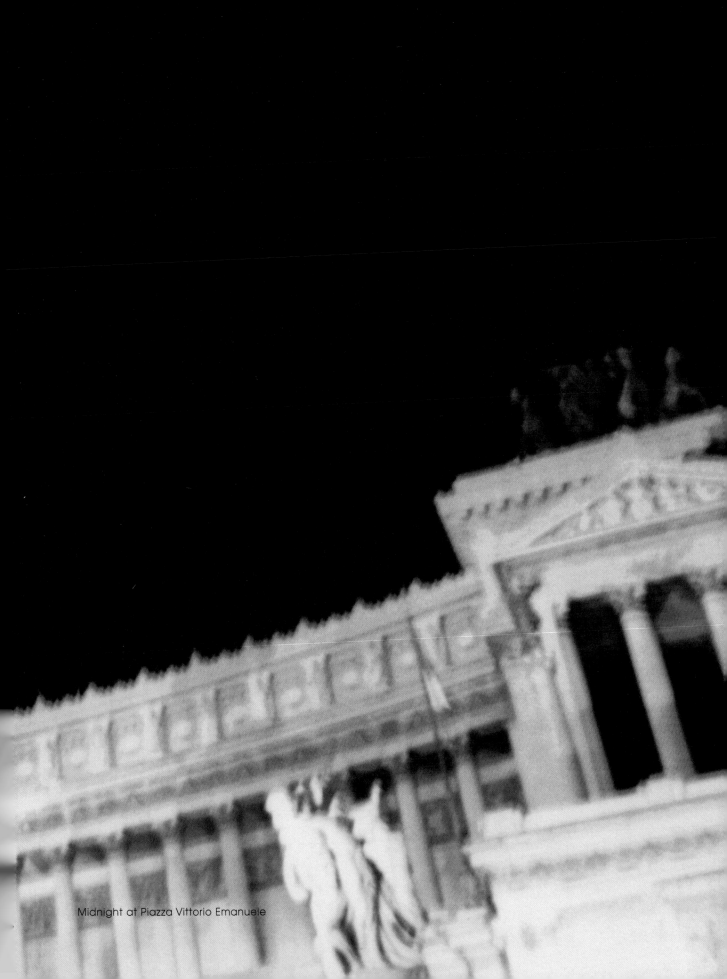

Midnight at Piazza Vittorio Emanuele

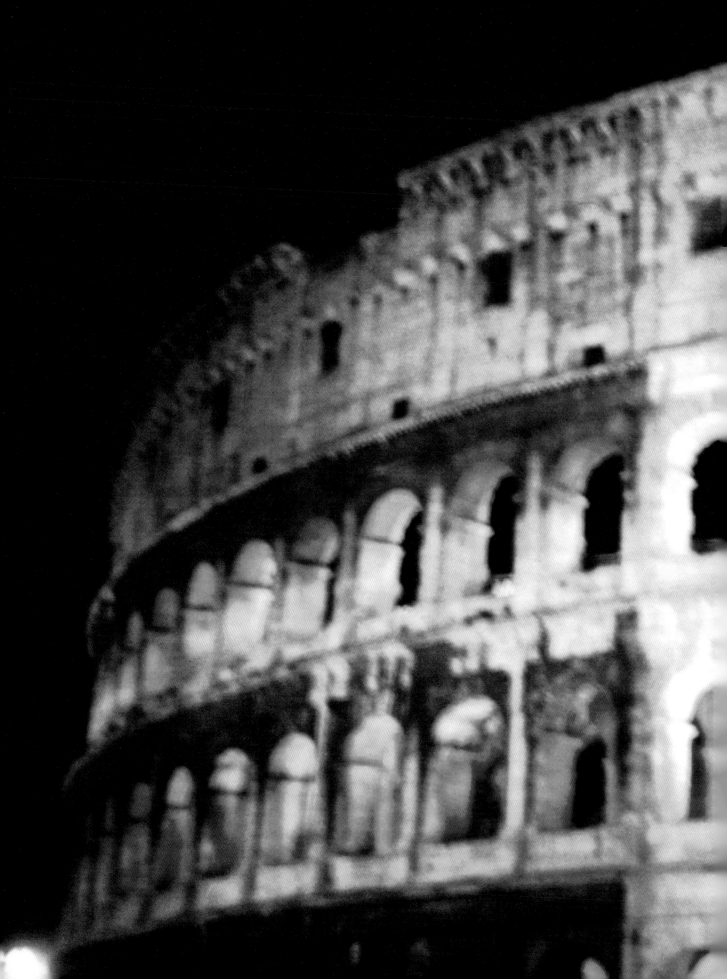

T When we reach Rome the sky is completely dark. Stephen is in quite an ecstatic mood, and so am I. This sort of evening, spent traveling toward the sunset with the wind rushing past is the biggest reason that I like to have a car. Since I had first arrived in Italy with the woman that I'm caring for I had often had the wish to steal away, even if only for a few hours. Today, with Stephen, I did just that. I had decided as a surprise to drive him all the way to Rome, instead of to the train station. It's a surprise for me too. It's Saturday night, the streets in Rome are really crowded, and we both know that we can stay only for three hours or so. We go to meet some friends of Stephen's, in a pizzeria. I'm happy to be in a packed place, to have the company of hundreds of noisy strangers. After the lonely months in Turkey, I wish I could stay overnight here, but I have to get back to Terracina. So we take it easy. It's a summer evening in Rome, and I am so thankful to have been able to enjoy this unexpected visit. Stephen enjoys feeling free again, after the past few days of emotional ups-and-downs and spending a little too much time with the old lady. I think it had been quite difficult for him to deal with her. At her age of eighty years, it was unbelievable to her that there was someone who wasn't able to speak German. I still remember this funny scene when Stephen had tried to open the door for her, without knowing which key he should use from the hundreds in her pocket. She became strangely so upset that she was raising her voice at him, as she often did with me in these sorts of situations. I arrived then a minute later at the door and saw only two red heads, one hysterical and one nervously working with keys at the lock.

S Glad to be out of there and in Rome! We sit at the Piazza Navona and it's a Saturday night in summer, so it's like a carnival, like that piazza scene in Fellini's *Roma*. Anyone and everyone all at once. Then we drive around with the roof down, past the Coliseum, past the Vittorio Emanuele memorial with birds flying in circles overhead, catching the light from below like eerie fireworks in slow motion. We were walking a bit later, a group of us together, when one of my Roman friends stopped in front of a huge door. He told us to look through the keyhole. What a funny idea, but it seemed to be a common thing because there were other people in line to do it. Now it was my turn. My God! You had the most spectacular view through a garden and in the very far end at the center of the horizon stands St. Peter's Cathedral, illuminated in pure, glowing white light. I would like to spend this night in Rome. Together. Instead, Tobi drives me to a street junction. I step out of his car and kiss him goodbye. He has to drive back to Terracina before dawn breaks. Our magic carpet ride is over.

Coliseum

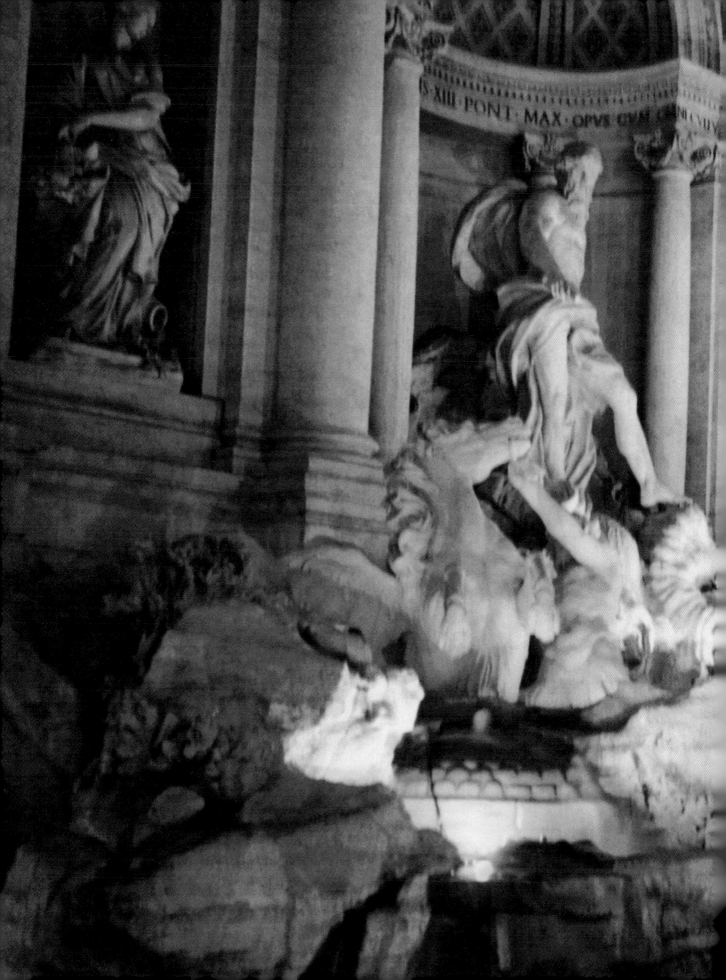

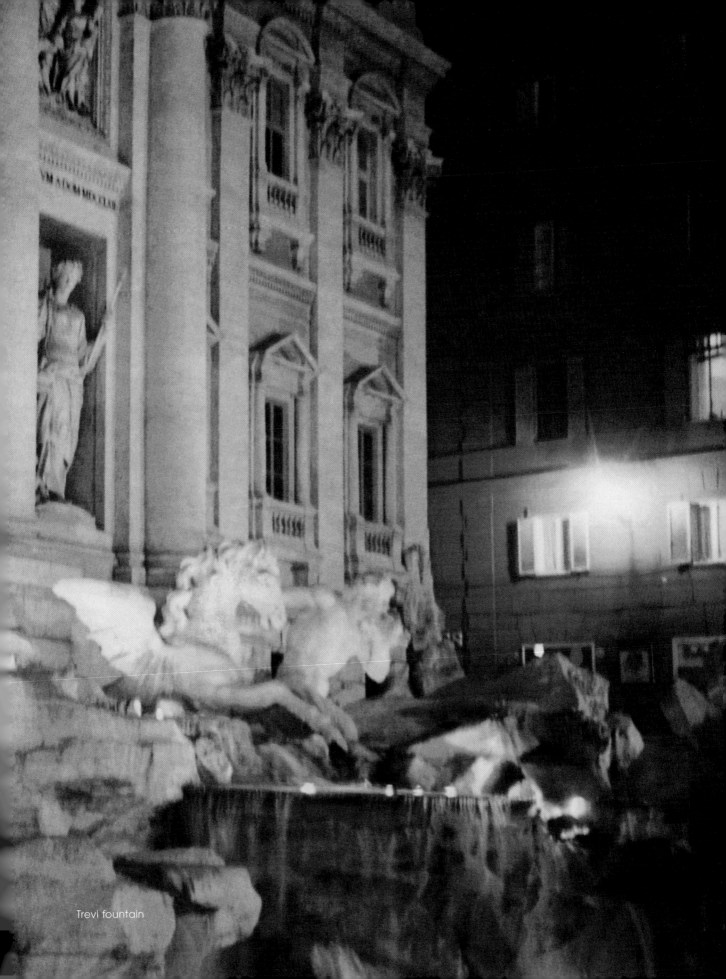

Trevi fountain

rio

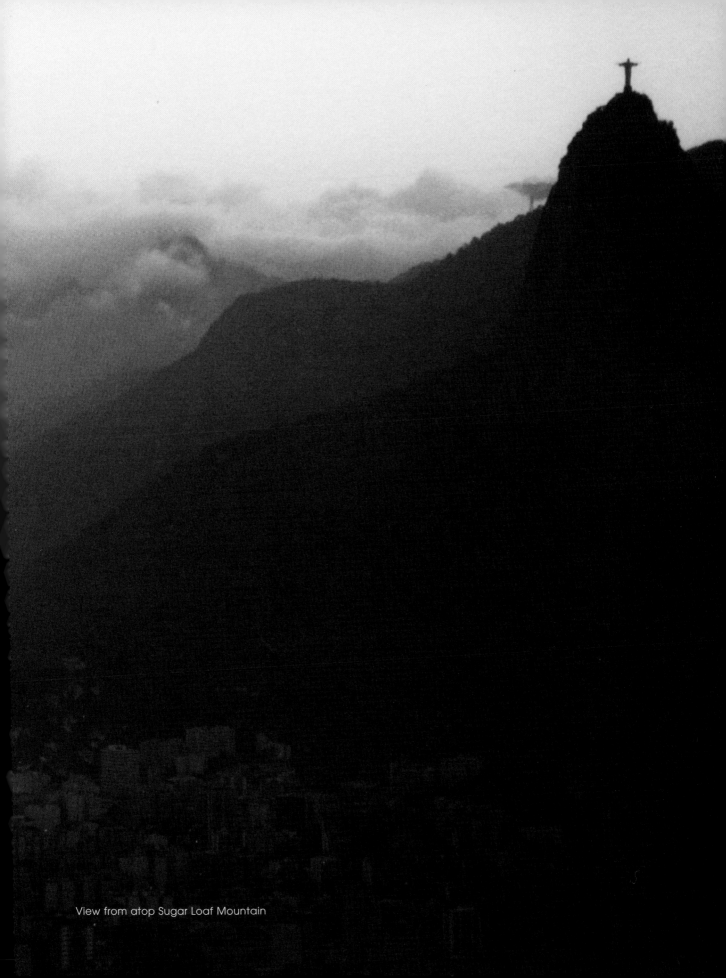

View from atop Sugar Loaf Mountain

S In Rio, Tobi says he has a surprise for me. The evening after I left Italy, he went back to photograph the drive we had taken from Terracina to Rome. He did capture it. Somehow he made time repeat itself. The parade of black clouds reflected on the black hood of the car, the sunset, it's all there. It's wonderful.

Heading for the top of Sugar Loaf Mountain in a cable car, right in time for sunset.

T Do you remember our first day together in Berlin? The visit and my thoughts while walking through the Bauhaus museum. We had known each other for only 48 hours. I spoke with you about dreams, what this word and concept means to me. Sitting here nearly one year later before this amazing view I think about this again. You know my dreams almost always involve gardens. I know you understand more and more about this dream of mine, especially after we have traveled, after we have visited together some of the most beautiful gardens in the world. And you can see how many similarities you find in your dreams regarding your work with images and design.

We spoke about balance in art and in oneself. Your inner ideas, your dreams are expressed in the form of pictures and images; my garden dream and I wait patiently in my soul for their time. I think that the patience, the waiting, and the realizations should be seen as parts of the same thing. We have decided to describe "the best things" in our work, and we both believe, like a child does, in hope and in the future. We both try to represent this in our work so that we can share these beliefs with others.

Here in Rio we find a glorious example of man-made/natural harmony in the Botanical Garden. Right now, I am incredibly thankful to be a visitor to these amazing garden spaces all over the world. Places with philosophies I have long respected, and now have been fortunate to experience in some way for myself.

Most of the famous garden artists were painters or writers, they were not landscape architects by trade. They built their illusions in these living arrangements, their gardens. Like the french painter Monet in Giverny. His painting of the waterlilies which he himself had first envisioned and then planted, is an example of this kind of connection in art.

But the garden itself is the living ideal, it is a live work of art. It includes morning, but only in the morning. It includes a thunderstorm, but only if there is a thunderstorm. That means that I as a gardener should think about every-thing that a space could possibly include. It is a space which changes its dress day by day, night by night, season after season. One must think about

A boat leaving the sunset

Botanical Garden, Rio

Parque Luz, São

the dimension of time. Time includes everything: youth and old age, nice days and bad days. A garden includes the same. A garden is fully alive in the summer, sleeps during the winter, and is born again in the spring. The constant motion of a garden requires a person who desires to understand and care for its spirit. This person, the gardener, must have a certain sensitivity and an ability to select elements that should grow or die, that should be trimmed or be allowed to grow. You have to listen carefully to what the garden wants to tell you, to the story of the place. Then, perhaps a balance will be created because of the relationship between the person and the space.

Often when I start with a garden-project I ask the client that I first be allowed to do one day of "weed control," and that I would like to be alone in the garden. During this day I sit or walk quietly in the space, and listen. I pay attention to the sunlight of the morning, to the afternoon rain, to the shadows stretching long into the late afternoon.

Often in these moments of attentive waiting I think of a photograph I took many years ago, and the day on which it was taken. It is a picture of an old woman, a hundred years old, dressed in a beautiful white dress. Her hair is completely white, like a crown made of summer-snow crystals, and she sits inside a hazy cloud of green and golden sunlight in front of me, at a white table on a white chair. She watched me in stillness, and I thought to myself then, "Garden art has time. She can wait." Years later when I started my landscape company I founded it on this idea which I felt so strongly about. When I lost my company, I felt at first that I had failed something of incredible importance. But then I remembered these words, and that the truth lay, for me, not in the actualization of the garden itself, but in the containment and push forward of the garden inside myself. I think now, maybe, I will never have the chance to create these gardens I dream about. But I see them growing in myself, and perhaps there is no need to move them into our world, to build them, to plant them in the earth. The future will tell me what feels right, and perhaps these garden dreams of mine will even be realized in other forms...

Everybody must take care of his "inside-garden." This means, to me, that you have to take care of yourself and your world. You should treasure innocence and sensitivity by remaining open as much as possible to this wild outside garden, or world. During my work on my dissertation, I had asked myself what "garden" and "landscape" meant to me. I sat down in front of a landscape in Germany just as we sit here today in front of this ocean and sunset. The word "garden" in German translates to "the close sheltered space". The same term in Latin means "paradise". I think of a garden as a place some-

where between Heaven and Earth. If a garden-space includes more than purely functional elements, it may be called art. Garden art tries to capture and translate for the visitor the spirit of a space. It could be, for example, the spirit of a lost time, like Rio's Botanical Garden that we visited today, where the park and the people appear frozen in a nostalgic dream of the past. They stood in harmony in the sun-spotted, shadowy morning together. If you were to describe "nostalgia" in art, this garden is perfect, to me, in the way it has shown itself today. It is a place where lonely people meet each other. This would be the place where I would go if I thought about being apart from you again. Today, I was greatly affected by our visit to the gardens in Rio. I understood how the landscaper had had this beautiful image in his mind of what the space would in the future grown into. He dreamt it, he planned it, he built it, with help I am sure. But he never saw it like we saw it today, because those trees took a century to grow. Today the garden is mature, and his vision has become reality. As a gardener, I have a strong belief in the future and in the existence and role of time. There is no hurry. Gardens have helped me so often throughout my life. I say, if one wants to find oneself in a place, go into a garden. For example, if one feels sad one can find a sad garden; if one searches one will find it, or it will find you. It may be a grey quiet place like the Botanical Garden. It may be the autumn forest in Hergenrath. Our relationship is founded in belief and interest in each other. I feel I have carried ideals inside me for a long time, and then I see in front of me the reality of a strong and powerful being. You are someone different than me, you speak your truth in another way, yet somehow I find us saying the same things. It is like good music, this harmony we create in our time together, and in our time apart. Sometimes it may be called love. Everything that we are should be included in our work and in our everyday life. These inner pieces of us need time to develop, we have to help them along. It is as I tell you often when we are apart, "it is only time." Do you know these lyrics? "I believe in the future... I believe in hope... I believe in love... I believe in you... I believe in me." To me they mean, dream all the time and try to realize your dreams as much as possible in your everyday life, and believe in the power of hope in affecting what is still to come. We have started to share each other's dreams, to plant a story that is ours, and the future will bring what it brings... It's nice to live inside today knowing this, holding hope. Before I met you, I had met only a very few people who still trust in their belief in the real world. I had never seen such a strong one as you. I wish for myself that I can carry on as you do, once again. One day I will have the chance to paint my garden picture as you paint your pictures, and I will be proud to show my heart to you.

Tobi's back and the Sugar Loaf

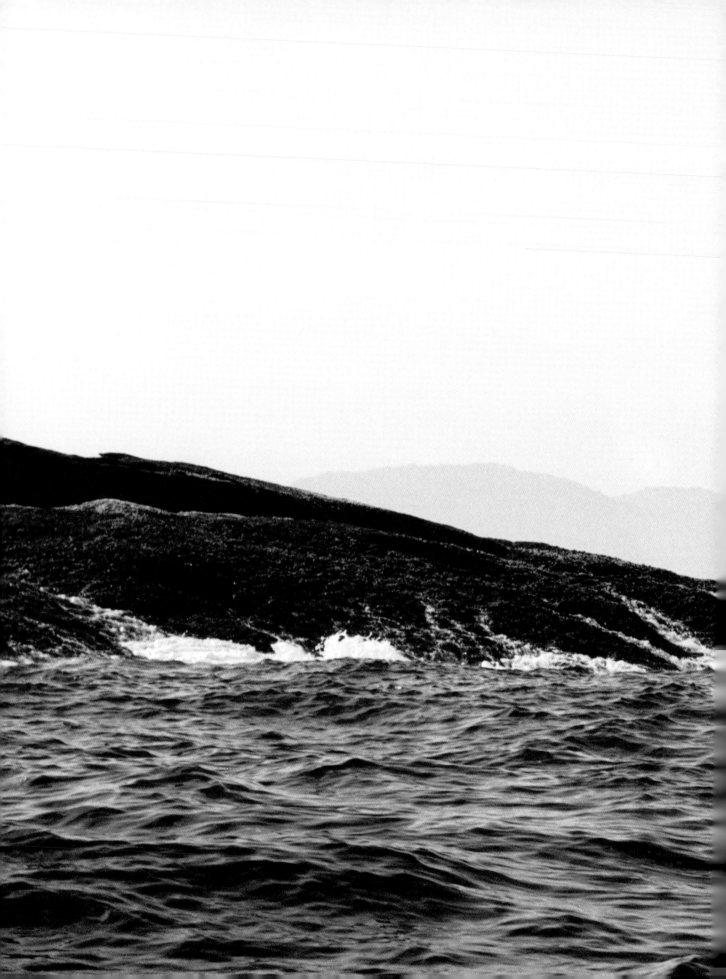

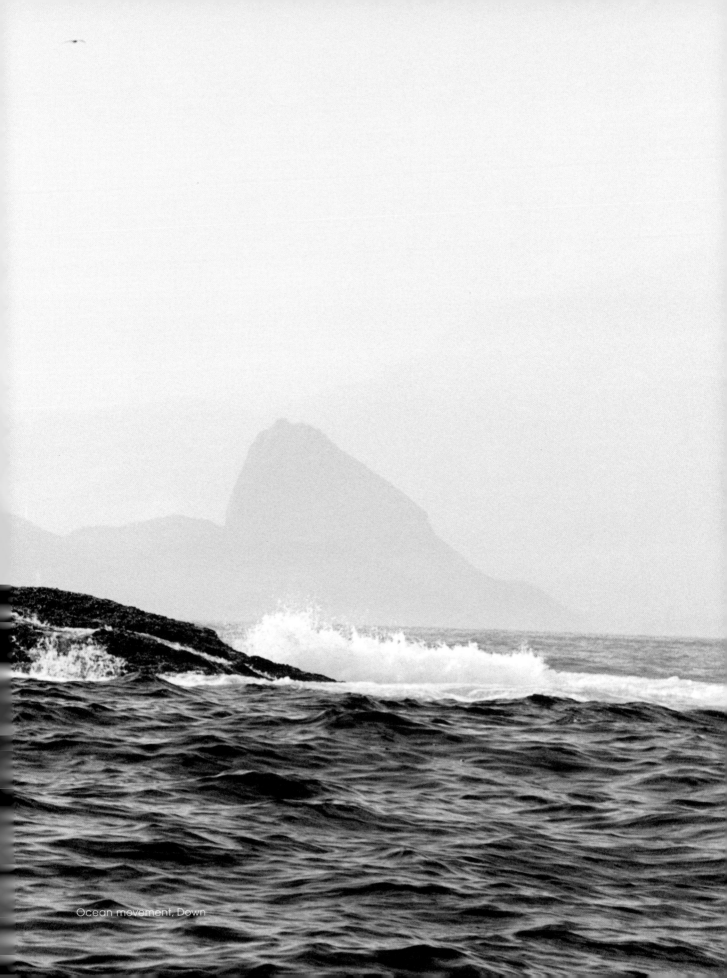

Ocean movement, Down

Ocean movement, Up

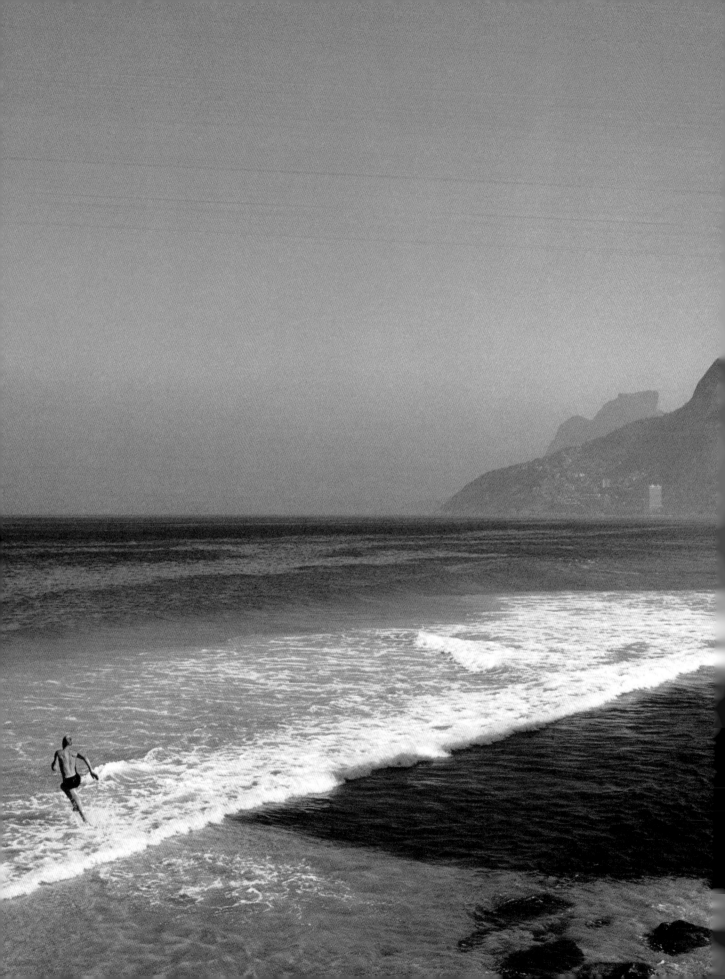

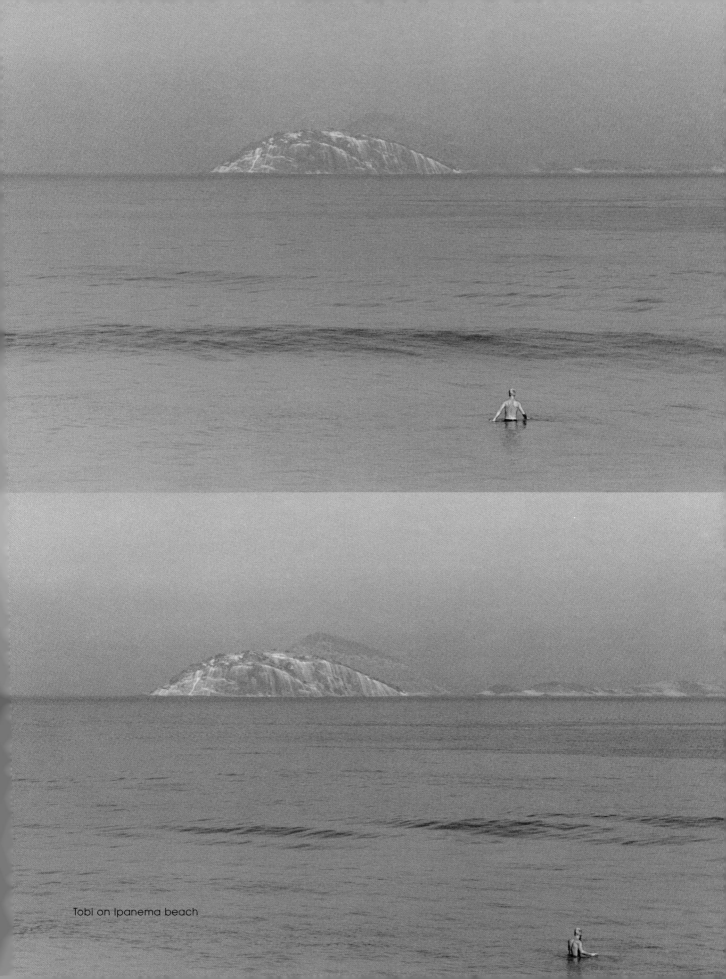

Tobi on Ipanema beach

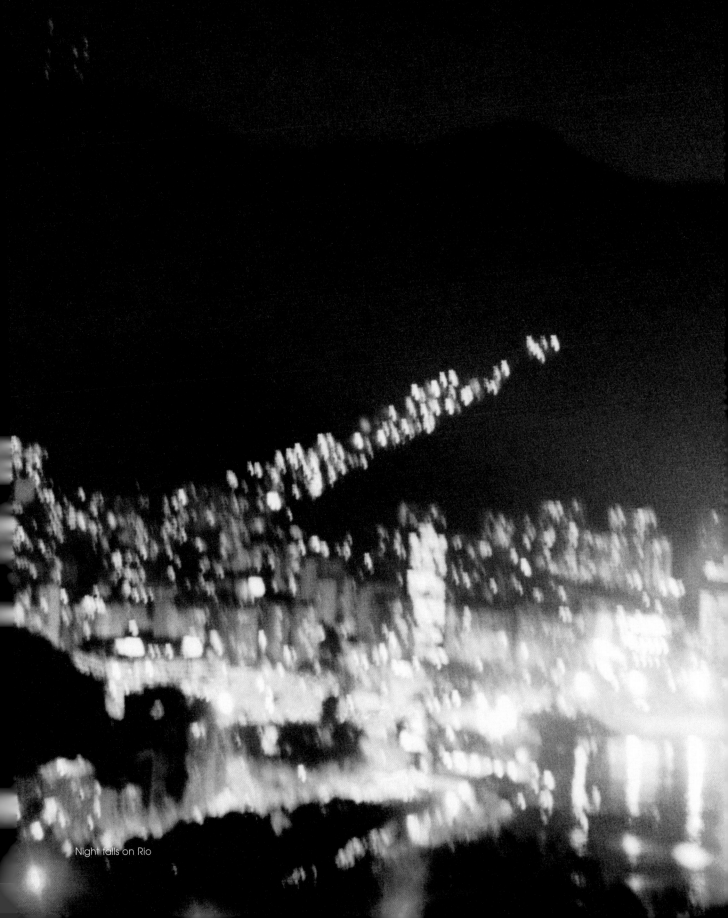

Night falls on Rio

Night flight

reykjavik

Rain curtain

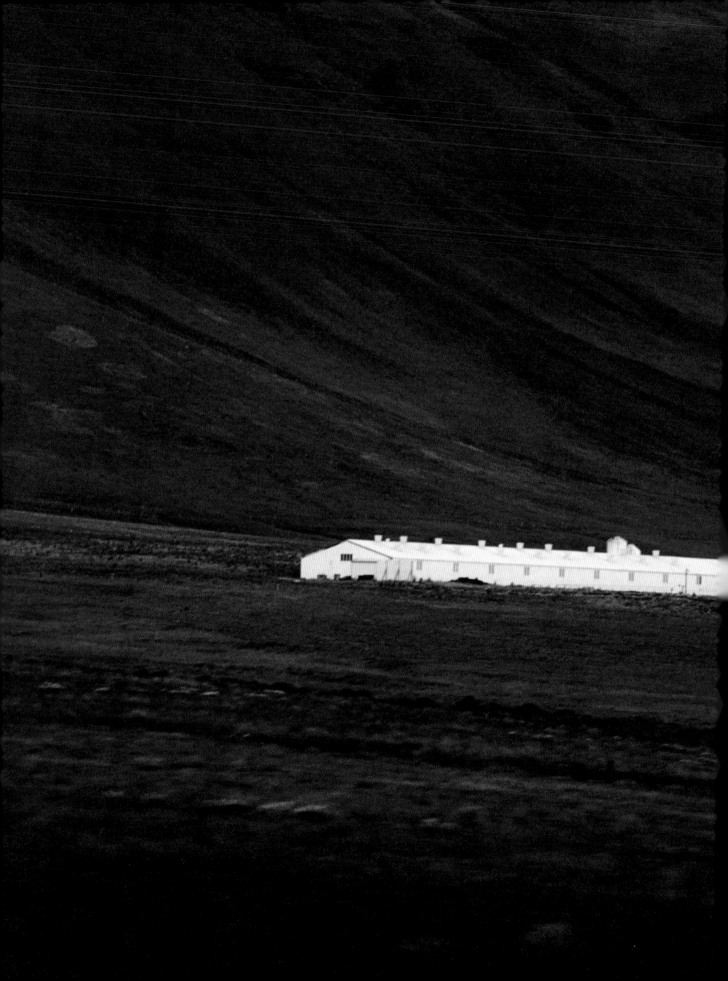

T We're on the airplane, flying toward Iceland. Stephen has gone to sleep right away. He is tired after the usual busy stresses in New York. Anne, a friend of Stephen's, and I are quite awake. She's really excited to be travelling after years of not. We talk and talk and talk. After dinner she begins to watch the movie, and at first I try to watch it too, but the words are too fast for me and the jokes I cannot understand. I listen instead to music, and look out the window. We are flying through darkness. I have to hold my hand close to the window so that I can't see the reflection of the cabin's light in the glass. Now

I can see the clouds better, they are deep underneath us. The moon lights them up to look like big milk soup, down there thousands of feet under the plane. The rest is sky, stars and the lights on the wing of the plane. I enjoy peering into this endless space. My thoughts about today and tomorrow have suddenly so much space. Between heaven and earth we fly forward, direction north. I get a little bit cold, so I turn my blanket up to my shoulders. It would be nice if Stephen would hold me now. Anne is fascinated with the movie. She eats nut after nut and there are still lots left. The

flight attendants stop serving, going perhaps to their space kitchen for napping. The rest of the guests are falling asleep too. Some are starting to snore. Only Anne and I stay awake.

The silence outside is incredible. I am so pleased to be looking into this cold blue darkness. We are heading north, farther north than I have ever been before, almost as far north as it's possible to go. North, for loneliness. For many years I have had a wish to go somewhere where I could get lost with my dreams in the space of open land. Allowing doors to close behind me and finding myself renewed, cleaned, fresh. Iceland. A place where children's dreams of snowstorms and lost snow princesses can come true. Rough nature without much life; just wind, rain, snowstorms, water, rocks, and oneself.

Suddenly I see a strange kind of cloud above our plane. It looks like a long white curtain hanging down from the heavens. I have to lean further against the window. This strange moving light crosses the whole sky. I have never seen anything like it before. Slowly we get closer, and I know it for the Northern lights, which before now I have only seen pictures of in books. A true miracle of nature. Here I am seeing the sun-winds millions of miles away from our star. I am so excited that I want to wake up Stephen. But he is sleeping so deeply, and even Anne has started to dream in her seat. So I enjoy this alone, and I enjoy a lot. I lose myself in the beauty of this flickering curtain scattered

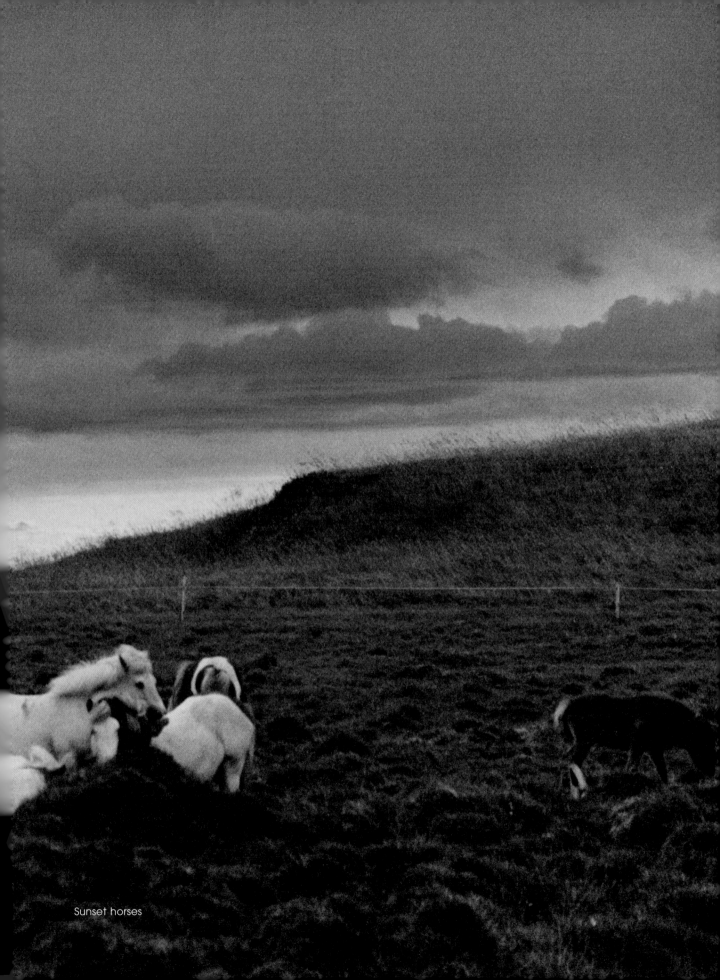

Sunset horses

Icelandic beach

Abandon

against the sky. I feel a huge respect for nature, that is always with me, but that is sometimes thrown against my heart larger than life when extreme beauty like this is in my sight. I start to feel so small inside this great universe.

We arrive. This taxi? Yes, it's ours. The driver is a tall rough lady with a huge round head who looks like a female Viking out of storybooks. She takes our luggage, and sets it into the trunk of the car. I don't want to make any trouble with this woman. It's quite cold. After the first few steps outside Anne knows that she has not packed enough warm clothing. No coat. I have to laugh. "Darling, we are in the North." We jump in the car. The next thing we realize is that these people of Iceland don't talk very much. It must be the cold and isolation that causes one to be so quiet. Right now, we take it as a blessing, because we are all quite tired. In the back-seat Stephen holds my hand and Anne lays her head on my shoulder. I look outside. For me it is such a wonder to be here. Finally we are really here in Iceland. I keep looking out into this endless land. I feel so free, watching this landscape pass as we drive. There seems to be no border.

The owner of this land is ice. This is Iceland.

It's a gift to be allowed to stay here. In the next week we meet a land of eternity. Where one feels worthless, free and lonely. You feel lost, you feel you, in this open land. It's a land without beginning, without an end, infinite, endless. Meeting yourself in emptiness, the realization comes that the anxious power struggles going on all over the world are worthless here, that this inhuman, wild land would swallow up anyone unwilling to respect its uncontrollable nature. Here there is a never-ending, frozen eruption of the earth's foundation. I can see a few farmhouses looking lost, lonely and weak. Often it is obvious that their owner had given up their dreams of owning and surviving in their home within rough nature. These empty houses are proof of the true owner, this cold, cruel ice entity, taking back her rightful property. Storms have broken out the windows, taken off the roofs, and killed the small thin trees that had struggled to live, in vain. I think people must become used to losing, here.

Soon we have passed the last houses dotting this land. We climb further up into the highlands. After a while, the brown grass lining the fields has disappeared. Now there is moss lining the wide land, but soon, as we continue on, this gives up as well. It seems there is a strict climate borderline which allows nothing living to pass over. A kind of unsurpassable line dividing the land into

green and black, living and dead. The freezing winds kill the plants, rock-fields use the space instead. Sometimes there are a few bits of scattered moss that try their best to survive, like the houses in the lower lands.

We left the world of humans. We left the space of life. Now we reach a land of cold and color. An ocean of stone fields in a hundred hues, clouds scattering the land into sun and shadow. Soft black, deep and golden brown, yellow, every color you can imagine floats like a drunken stream at the ground in front of you. Flat water fields complete the gentle confusion of this nature painting. Then this painting lying before us grows to include the third dimension. In the background we begin to see mountains. They appear quickly larger as we move toward them.

The first patches of snow are a small taste of what comes next. First, we discover a small waterfall, slightly frozen. Then, there he is. The glacier. Ice blue cliffs stand on top of the black lava mountain walls. Slowly we are coming closer and closer to this frozen emperor of time. Thousands of years of snowstorms have gathered here, caught in this block of ice. Never before have I seen a similar nature personality to this massive frozen being. It grows larger and larger in front of us as we approach. Turquoise-blue and white masses struggle against the peaks of the mountains, who seem almost small beside this unmoving ocean of pale eternity. You can't see the end, because there is no end. Heaven and earth meeting in ice. Not much lives here. The owner is ice. It is Iceland. Thank you for existing.

S Back to me sitting here in New York City, and Tobi is thousands of miles away. I am much more pleased with the photographs from our trip to Iceland than I've been with any before because the quality is so much better. Tobi had given me a really good camera before we arrived in Iceland, the most precious gift I think anyone has ever given me. I'm done for good with my little instamatic.

So, back to both of us in our separate little "boxes," as he likes to call it, trying to visualize things, moments we've spent together. At least we have these photos of our experiences together, along with our mind-memories and imagination. I keep thinking, this is a part of what has kept us together. Because there are certainly some who would not have bothered to go on, considering the distance and all the constraints of time. Like I said to him the other day, it's a relationship with a border. Always a border. Always the distance. Always something to move toward, to reach and hopefully surpass. But anyway, here we are sitting as if we were together looking at pictures, and whatever difficulties we may have had, I feel are being washed away at

Tobi's lava walk

this very moment, because I am looking at pictures of Tobi and myself staring at a glorious sunset that really looks like Mars invading or something like that, or clouds that look like they are cracked ice, or cracked ice that looks like they are clouds. Or this incredible scene: we saw rays of light coming through the clouds in front of that big mountain, was it Mt. Esja, in Reykjavik, and I swear you saw rays of light like it was God speaking to Moses, and stuff like this can be very powerful, very spiritual and very humbling at the same time. You are looking at these scenes, and remembering them, and it wouldn't matter whether one of us was in a ditch and the other was in a throne room, and it wouldn't matter where we would be six months from now. All of that seems so minor right now, and that is what I mean by if it weren't for moments like this, and pictures, I don't think we'd be together. Because I just can't picture myself right now calling him to say, you know what you said to me in Reykjavik, well I'm really annoyed by that, and I've been thinking...

And the most exciting part for me is looking at all his pictures, because he takes far more pictures than I do. I can stare at a rock only once, you know what I mean? So I look at these pictures that he's taken along the drive and I was either chatting away or fast asleep and so I miss all these moments, and I say to Tobi over the phone, how funny that you caught that fence climbing up that hill, and strange that you saw this, and it's like looking at things through his eyes. You know that part of the actress Laura Mars in John Carpenter's film where she can see her own back because for fleeting moments she catches glimpses inside her head of what the killer sees? Anyway, I thought to myself, there is a very profound side to this, and I can't even begin to describe it properly, but two people in different parts of the world, brought together by what the other one sees. And you are thinking, thank you, yes thank you, for making me see this. Otherwise I would have never experienced it! And like I said, whatever other day-to-day problems we've had seem so minor...

Blue lagoon

Land and ice

Cloud

Ice crack

Glacier scars

Lip-shaped cloud

Never ending sunset

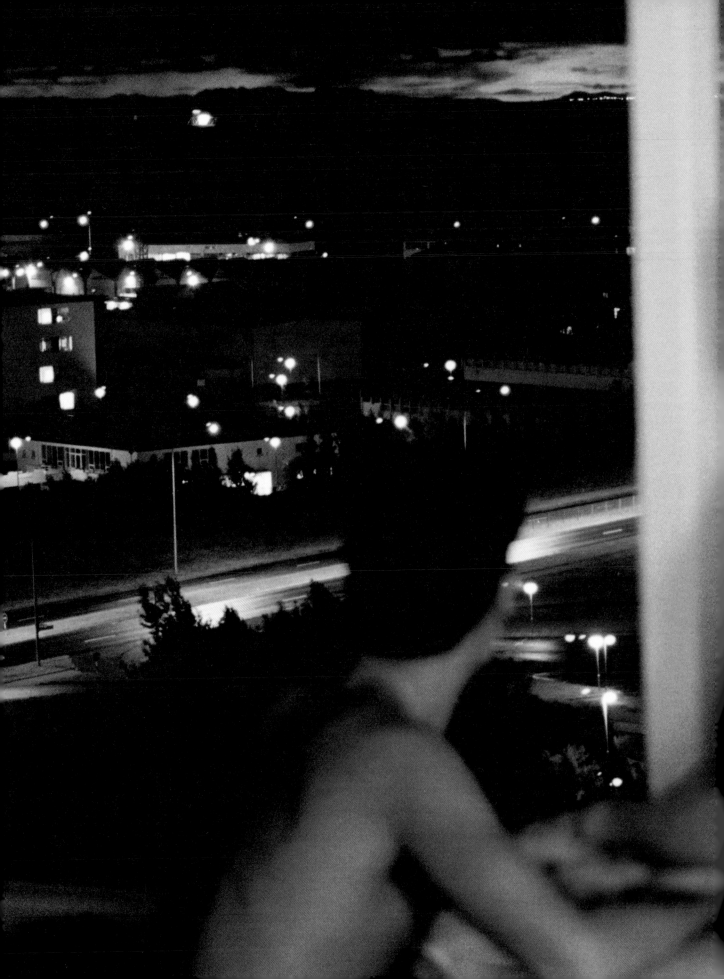

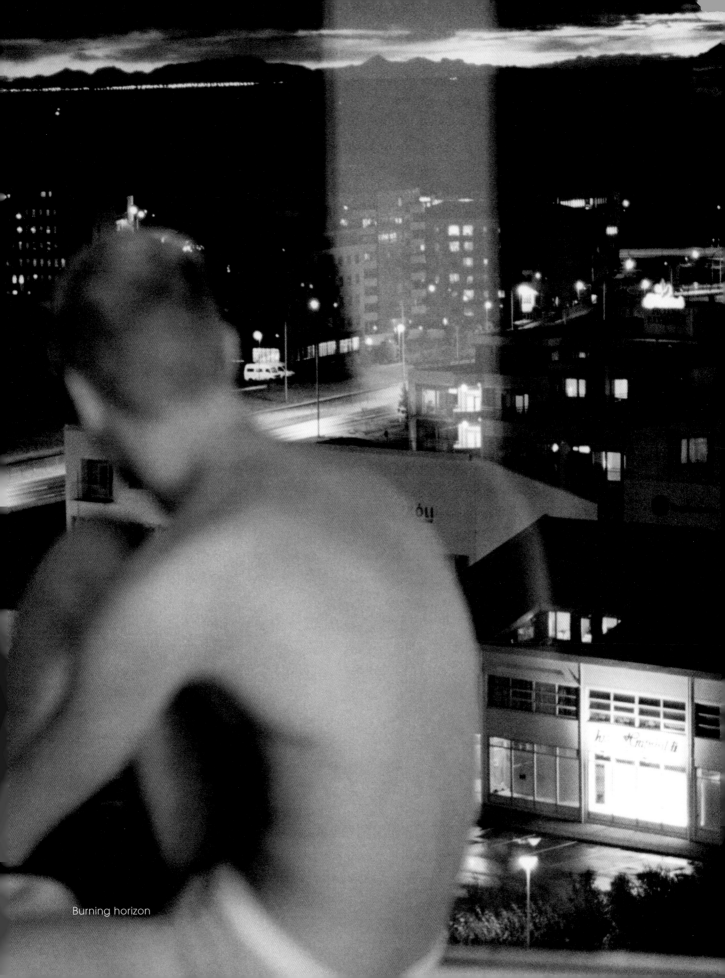
Burning horizon

Light flight

Strangled mountain peak

stockholm

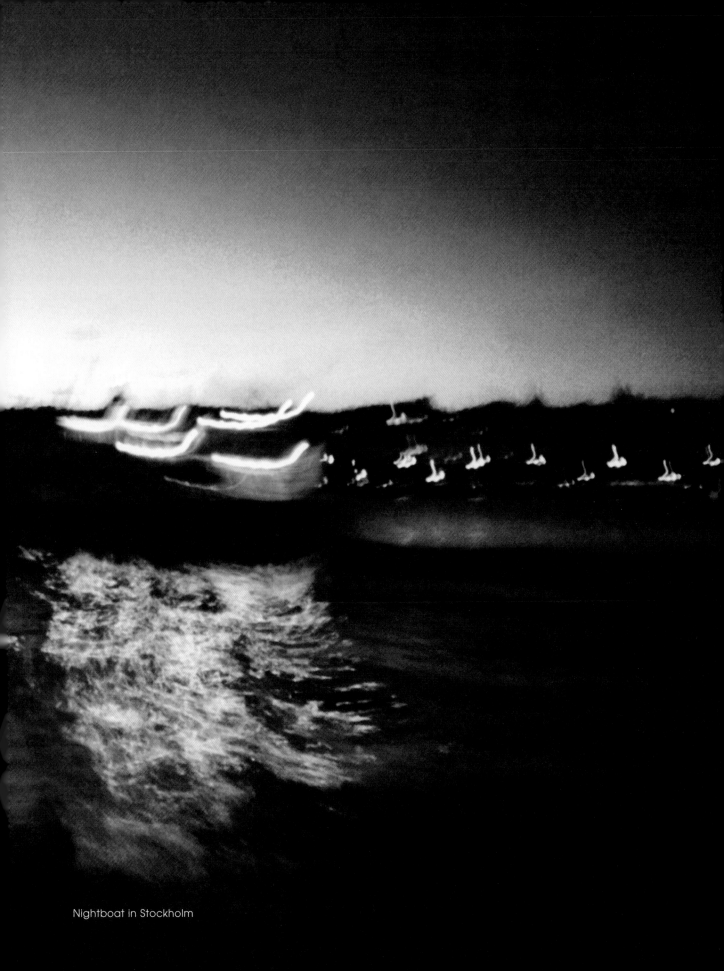

Nightboat in Stockholm

T Stephen and I are finishing a project for an exhibition in Stockholm, and we are unwrapping the artwork. I have to stop at the first issue. It's already quite late, and there is no one except us in this hall. I'm quite touched by what I'm seeing. Never before this have we had the chance to sit calm in front of his work. There are pieces of cheap paper, most of the images in black and white. Drawn bees and sketches of people in pen and inks. On the cover is a

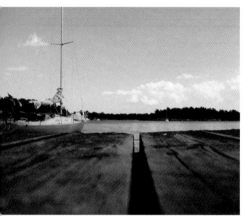

rose, just opening into flower. A rose, like the friend of the "Little Prince." And the title of his company is "Visionaire." I see how his dream in printing is truly related to my dream in gardening. At the edge of the table Stephen is carefully moving his issues, from first until most recent. It reminds me of the way I order my photobooks from past to present. I ask him how he can have kept on so determinedly, with such good work, for ten years...

Back at the hotel...

I put the telephone down. I have to sit. Nice white good-weather clouds crossing the sky. It's fresh outside. The best freshness that you can get. I enjoy the cold breeze. I can't quite believe what I've just heard: "I'm free! I'm free again." This certain story is finished. An agreement with my bank has been reached; they have agreed to accept 30,000 DM as payment for my bankruptcy. It's 20% of the original amount, and it's already been earned in Turkey. After two years it's over. Never did I think it could be taken cared of so fast. But it's over. I owe the world zero, nothing (in terms of money at least.) "We accept the agreement, Mr. Schweitzer." Like an electric shock it rushes down from my brain into my entire body. Tobi, you can continue on with your dreaming. No interest rates, lawyers, amounts, no remainders... only you. Only wonderful friends, a big dream of garden visions, four homes, and a belief in hope and future. Enjoy life, be free and independent, be you.

These emotions start to tickle in all parts of my body. Like a big huge wave they smash this big rock in my stomach against this so called wall of "bankruptcy," to destroy it forever. I can carry on to fly wherever I want to. Wherever the stream of life will take me. I passed this test. I found peace with my past.

I look down onto the street where the shade covers the walking people. I can still feel the last power of the late summer sunlight on my skin. I press my body against the railing. I can feel my hand holding the cold iron railing. I am! It's so good to be. two years I've had this mean friend bankruptcy who told

me ten times a day, you are guilty. A new clear future, like this fresh breeze, wakes in this morning. I can continue to run ahead with hope. The wall is knocked down. And behind this there are all my old and new friends who love me, who have all this time. I can picture all of them as treasures who have protected and cared for me. My mom, my brother, my sisters. Mrs. Preuss, Jan, Stephen and so many others. They had waited for me to feel free. Because of me. I have to say thank you to them all.

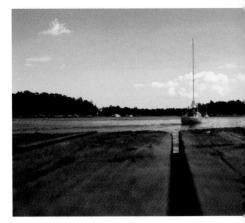

Stephen waits there to take my hand to surprise me with his dreams. It's like leaving a snowy foggy hill where you aren't able to see anything in front of you. The blank white that feels so dark. I had tried my best. I had only tried to take the risk to build the space to encompass a dream. A dream of gardens to share with people. Life had taught me to love this garden dream, and I had tried so often to explain what gardens can mean. Hundreds of times I had tried to take people with me to these places of eternity, of peace and hope within themselves. An innocent clean space of privacy, to be shared. I arrive back into spring after a strange long winter, which I realize now was not always so sad or dark... "It was only time." Now it's time to start the engine again for leading myself into a new direction. I don't "have to" any longer, I "will do..." my life, hopefully with more awareness and sensitivity than before. I feel able to paint again a picture of beauty in life. I will try to share this great gift again with as many people as I can, as I have always done before.

"I'm free... I'm free!" (jump... jump... jump...)

I will never forget this friend who has stayed by my side wherever I was, wherever we were. My Stephen.

A song jumps with me up and down: "Vision of eternity. I speak with angels in my dreams, I float with the stream of time, I believe in the future, I believe in love, I believe in hope, I believe in you, I believe in me..."

I know that another cloud will come. I hope it will be not bankruptcy again. I already had that. Life includes black and white, it will always be that way. I have enjoyed so often this strong picture. This picture of the world in black and white, like the struggling mountain in the arms of the emperor of ice. This land between frozen time and moving clouds. Going forward, my way, my direction seems clear now. And if clouds become snow and snow becomes rain, I will still see a way before me and I will follow this path. My way lies between dreams and being. A little bit of both and sometimes some-

The boat leaving the pier

where in the middle. Discovering new parts of this tricky, wonderful, mean, beautiful world we live in. I want to and I will.

I need things to find solutions for. I don't know what I'll be when I grow up. Maybe a "visionaire," maybe a landscaper, maybe many things along the way. I don't know how much of the color "black" life will use to paint the next story on the white screen of that wonderful world. I will jump over the walls. But one thing I promise. I will stay who I am. Me, and you.

Cup couple

Be back...

new york

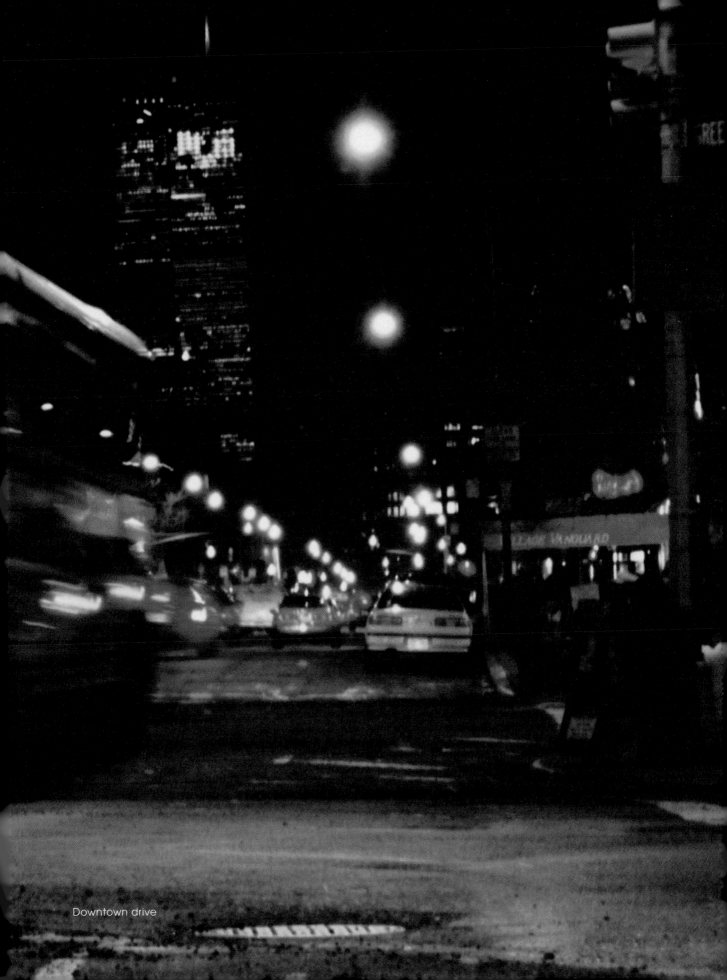

Downtown drive

S So this is my story with Tobi. Part wild cat. Part nature boy. Party kid and dreamer. His mother calls him "Le Petit Prince," and my friends refer to him as Peter Pan. Throw "driven young landscape architect who opened up his own company with two friends and a wheelbarrow out of his one-bedroom apartment in Berlin" into the mix and you may be on your way to getting an idea of what kind of person Tobi is. And then of course, there is the person who has been photographing and recording everything around him, (albeit trees and rocks for the most part,) and who can get teary-eyed talking about his first treehouse or the forest he grew up next to. Oh, and there's the boy who said at 19 that he would like to take care of plants and older people, and so the constant shuffle between landscape jobs and old people's homes. He often told me about doing community service at 19 and watching so many older people die in front of him, and how this made him want to give life. This led to his beginnings as a landscape gardener, that's led to this person Tobi. I always saw him as Le Petit Prince of the plant world. And when you think of Le Petit Prince and Peter Pan, you don't think of them as having homes, and that has been very much the case. Soon after meeting him, I started to get confused: Now let's see, still living in Berlin, but just got back from living in London, (things just didn't work out.) Okay, might not be able to stay in Berlin because of financial issues, he has to go to Zurich from time to time because that's where his mother lives and he helps her out with the old man she's taking care of, but his real hometown is Aachen, a German town close to the Belgian border, where his dad lives in the home he grew up in. But then more home to him now is his sisters' home in Hergenrath, Belgium, across the border from Aachen. If you start getting a headache reading all that, that is what it felt like. So that has been one of the difficulties, never ever asking, "Where will we meet next?" You are simply meant to cross paths with him and if, like a butterfly, he wants to fly over and sit on your shoulder for a while, then he does it, and it's lovely when he does. But needless to say, Tobi was a very strange creature to me. Think Peter Pan meets Mogli. Even today he baffles me.

The one thing I hadn't anything to do with before meeting (or so I believed) was nature. It is bizarre to me even today that I am working on a book of landscape pictures. When I think about the past year... the nightwalk through the woods, the campfire, the sunset drive, the midnight talks and the morning teas in his gardens... And then there was his family whom I feel accepts me more than my own. This strength and power from someone vastly different but strangely similar. A richness that comes with character and spirit. The treasure in having someone at my side who can read my mind and see right through me.

I can't believe what Tobi just told me over the phone. When he's done in Zurich, we'll meet next in New York, and then, that's it... No more travelling. He wants to

come to New York for a few months. This is it. New York. He never stayed before for more than ten days. He decided to come. I didn't ask. You couldn't make Tobi do anything he didn't want to do himself. What happened? Did he get hit in the head by that glacier in Iceland?

He doesn't realize that we'll be busy when he gets here. Our landscape pictures will be published into a book. I will wait to tell him. But there's one catch: our story will be told. And we both have to speak. I didn't ever know how to say things, even to him. All these analytical questions of life and what lies behind things… now I have to face them. But that's fine with me. I realize that from all this travelling the one treasure I have picked up along the way is Tobi. He has changed my life and opened my eyes to the world. The bird with the broken wing has shown me the power to fly. All these things and more Tobi has given me, although he doesn't know it. Now he can help me find the words. I want to talk about him, about landscapes, and about us. I want to tell people how wonderful life can be.

No more travelling? I'm not sure about that… I'm sure there'll be more travelling.

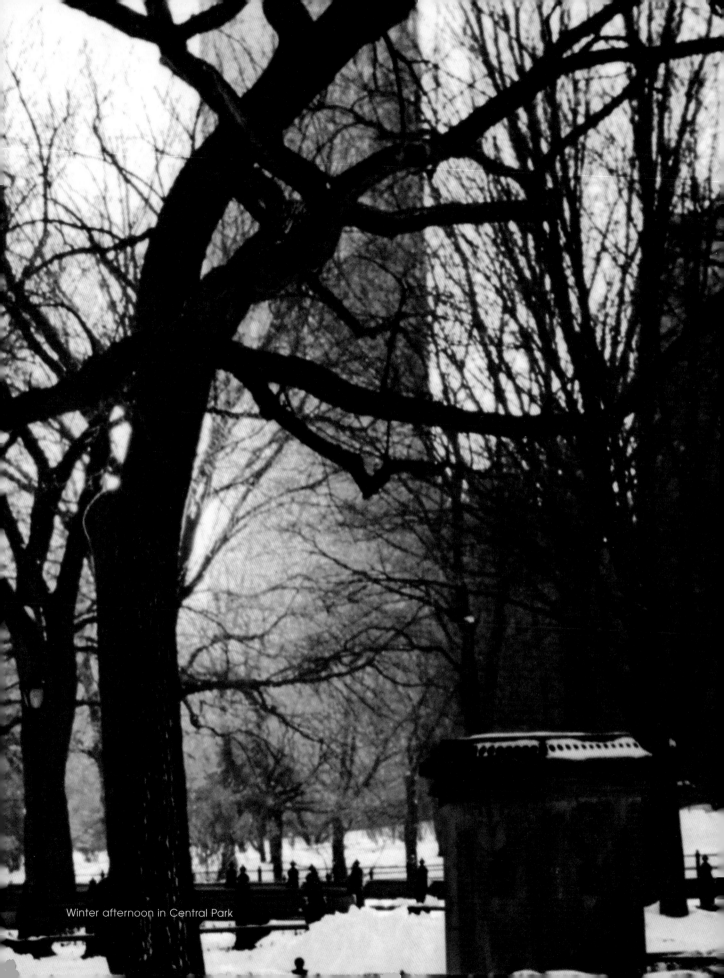

Winter afternoon in Central Park

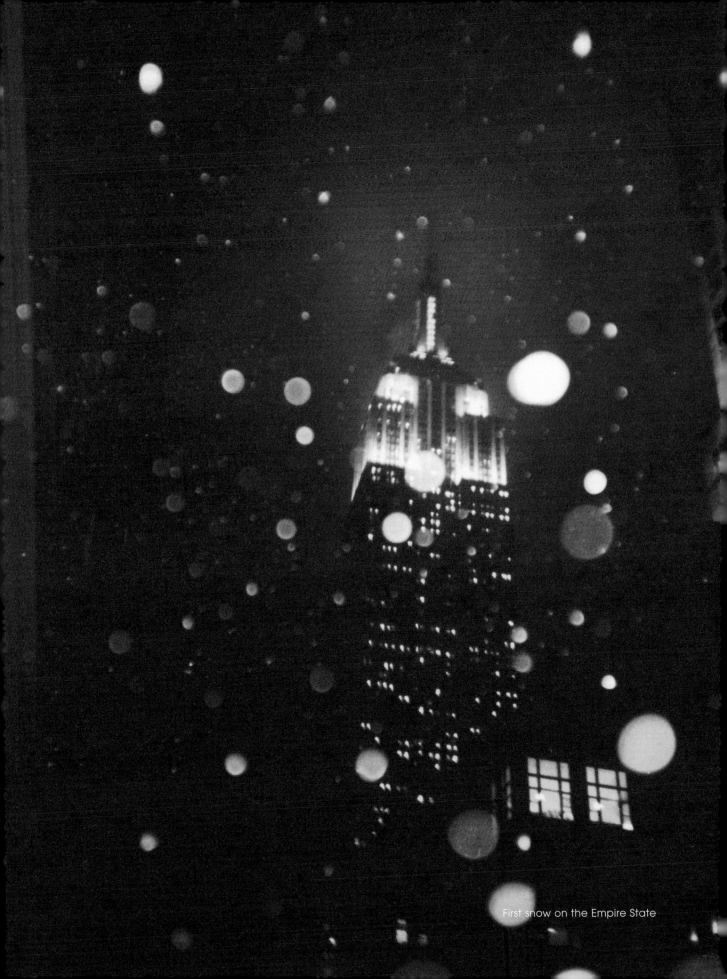

First snow on the Empire State

Sky waves

Powerful City

Life goes on...

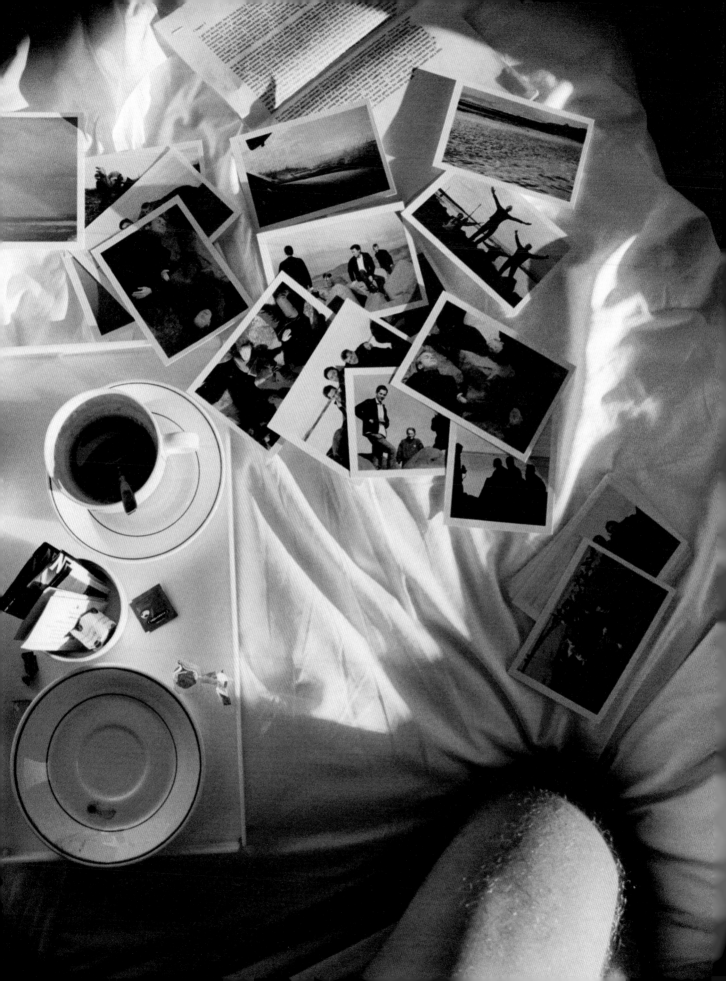

Memories

acknowledgements

Our deepest thanks to...
Mario Testino *through whom we met*
Karl Lagerfeld *and* **Gerhard Steidl** *for finding a very personal project to be one worth publishing*
Almuthe Bertschinger *who always asked the question "Where will you meet next?"*
Charles Miers *for first finding this story of two people's travels interesting*
Brett Cobb *for editing the first draft of text*
Heidi Pinkney *for editing the subsequent version of text*
Inez van Lamsweerde, Alix Browne, Christopher Bollen, Glenda Bailey,
James Kaliardos, *and* **Guilliaume Jessel** *for your opinions on the text*
Stephanie at Art Partner Paris *for first giving Stephen Tobi's phone number*
Mario Testino, Francesco Anton Serrano, Peter Bici, Hedi Slimane, *and* **Peter Bertschinger** *for additional photographs used in this book.*
Raja at Color Edge New York *for all the film and all the beautiful prints.*
Bill at the Travel People *and* **Esther & Co at Frenchway Travel** *for working on all the flights and enabling us to do all this traveling*
Bernard Fischer, Andreas Gerlts *and all at 7L and Steidl Publishing*

Book design by
Jason Duzanky, Greg Foley, Terence Koh *with additional support from*
Sean Ealey, Jake McCabe, Tenzin Wild *and* **the design team at Visionaire**

Friends and family who have supported and encouraged us along the way...
Mrs. Preuss *who always overpaid Tobi and for letting Tobi build his garden dream*
Christine Schweitzer *who let Tobi use her credit card and for being the best relationship adviser*
Lydia Schweitzer, Anne Warnock, *and* **Elaine Gan** *for all the love*
Ferdinand Schweitzer *and* **Anja Hase** *for your caring and all the hours you've listened to us*
Christian Schweitzer *and* **Xavier Buchholzer** *who gave Tobi work in Turkey*
Ursula Trüper *for dealing with all of Tobi's mail and bill collectors*
Stephan Knauf (Jan) *for always being there*
Martina Niebuhr *for giving Tobi health insurance*

To those we met on our travels...
Isabella Blow, Patrick Kinmonth, Ted Hesselbom, Rosemarie Vossen, Heida Jonsdotter, Erick Wright, Amanda Harlech, Joe Lupo *and* **Tony Formabaio, Fumiaki Ishimitsu,** *and* **the Ishimitsu** *and* **Nakano families**

Additional thanks to...
Giovanni Testino, everyone at Art Partner, Christopher Vann, Huw Gwyther, Nancy Gallagher, Wolf Sasse, Birgit Simon, Ursula Steinbuch, Tom Friedlein, Linda Ogwa, *and* **all the Turkish laborers**

First edition 2002

Bookdesign by VISIONAIRE

Scans done at Steidl's digital darkroom
Printing by Steidl, Göttingen

distributed by:
Steidl
Düstere Strasse 4
D-37073 Göttingen
Phone +49 551 49 60 60
Fax +49 551 49 60 649
E-mail mail@steidl.de

Orders can be placed directly at our
publishing house or via the internet.

ISBN 3-88243-555-0
Printed in Germany